*T*HE *S*TORY OF *I*CONS

Mary Paloumpis Hallick, Ed. D.

THE STORY OF ICONS

HOLY CROSS ORTHODOX PRESS
Brookline, Massachusetts

© 2001 by Holy Cross Orthodox Press
Holy Cross Orthodox Press
50 Goddard Avenue
Brookline, Massachusetts 02445

ISBN: 1-885652-42-9

LIBRARY OF CONGRESS CATALOGING-IN-PUBLICATION DATA

Hallick, Mary P.
The Story of Icons / Mary P. Hallick.
 p. cm.
Includes bibliographical references.
Summary: Explains the history,purpose, and characteristics of icons in the Orthodox Christian Church and describes how icons celebrate events in the lives of Jesus and the Virgin Mary.
ISBN 1885652429
1. Icons—Juvenile literature. [1. Icons. 2. Christian art and symbolism.] I. Title

N8187 .H35 2000
246/.53'21—dc21
 00026783

For the enlightenment of my grandchildren
Cheri
Chad
Tiffany
Melissa
Stephanie

CONTENTS

Acknowledgments

I want to thank the many who contributed advice, information, and support which motivated me to bring this work to fruition. Without their unfailing help, this book could never have been written. However, I would be remiss if I did not express my thanks and gratitude to the following for the invaluable assistance they afforded me. I have been greatly aided and they helped make my work easier.

Maroula Papantoniou of Athens, Greece made many trips to the Byzantine Museum on my behalf to obtain prints of icons and the permission to use the prints. These prints gave me the impetus to begin work in earnest.

Fr. Simeon of the St. Isaac Skete at Boscobel, Wisconsin, was most generous with the colored prints of the icons. He, also, gave permission for the use of the prints

Fr. Ted Trifon and Fr. Peter Papademetriou were generous with their time and advice. They filled in the gaps of my religious education and read the manuscript to see if it was canonically, dogmatically, historically and Traditionally correct.

Ellen Roach faithfully read the manuscript with an eagle eye. She helped keep the vocabulary meaningful and the readability of the text age appropriate for the younger reader.

Faye Spanos provided me constant motivation. Her inquires and concerns for the book kept me on task.

My daughters, Connie and Thana, were most honest in their criticisms.

Lastly, Dr. Anton Vrame, my editor, who saw merit in the work, guided and mentored me through the various stages of the book.

Mary Paloumpis Hallick, Ed.D.

INTRODUCTION

The story of the Holy Icons is an exciting, fascinating, and sensational tale. It is a story filled with love of faith, deep, dark secrets, cunning deceit, dreadful fights, many crafty spies, and finally, peace. These adventurous tales take us from the lives of the Apostles and the early Christians, to the present day.

The icons of the Orthodox Church are a very valuable part of the Church. They are so important that the Seventh Ecumenical Council declared that the icons deserve the same respect and reverence as do the Holy Cross and the Holy Bible. As the Holy Cross and the Holy Bible are regarded as sacred so are the Holy Icons.

True, many people show respect and honor the icons, but do not understand them. Moreover, they do not know the purpose of the icon. This has led to the improper use of the Holy Icons. For instance, in some Orthodox homes, the icons are hung on the walls just as decorations. Even though icons add beauty to our homes they are meant to be in places for prayer to God. It is proper to have a candle or small votive light before an icon. The icon and light reminds us of God's presence in the home.

Another example of improper use of the icon is that some people buy the icons only as a financial investment. Many icons, especially very old icons, are valuable. Like any precious item, they should be treated carefully. There are many very good people who buy and sell icons to churches and to those who want to give them as gifts or for a prayer corner in their homes. However, buying and selling icons only to make money does not show the proper honor, respect, and reverence they deserve.

Sadly, some say that it is difficult to understand icons. This is not true. To understand and to know the true meaning of the icon, let us look back to their very beginnings. The story of the icons begins with the very first Christians.

Part One

One

CHRISTIANS USE SYMBOLS

The first Christians used works of art and symbols to remind them of their faith in Jesus Christ. Using symbols and pictures also protected them. For nearly four hundred years, Christians could not openly practice their religion in the Roman Empire. The Roman Empire ruled all of the then known world. It was a very powerful empire. It was known for being very cruel to those who challenged it. The Romans did not want anyone challenging their religion. The Roman rulers believed in many gods, like Zeus or Jupiter, Hera or Minerva, Ares or Mars, and Eros or Cupid. The Romans also believed that their emperor was a god. The Christian belief in one God challenged the power of the emperor. Because of this, Roman rulers often looked for Christians to force them to change their faith. The rulers could be very cruel to the Christians. Many men and women were arrested, tortured and killed for their faith in Christ. A martyr is a person who died for Christ.

The Christians of the first centuries suffered very cruel punishment when they refused to give up their faith in Christ. Often the inhuman punishment of the Christians was used to entertain the Romans. For example, the Roman spectators in the arena watched Christians, who were bare-handed, fight hungry beasts. Either the Christian was able to kill the wild animal or the hungry beast killed the Christian.

Another form of amusement at the arena was for a Christian to fight a gladiator. This fight was usually an unfair fight for the Christian. The gladiator was an important person for the entertainment of the Romans. He was a slave, a prisoner, or a condemned criminal. These people were promised their freedom if they agreed to become a gladiator. If the slave, prisoner, or condemned prisoner agreed, then

he was trained to fight. He received special training and he learned to fight with a sword or trident, which is a three-pronged spear. He was also trained to fight blindfolded, with a troop of gladiators, or in a chariot. The gladiator was ordered to fight until either he or his opponent died. Obviously, the Christians lost most of the fights since they were not trained to fight.

The Romans had other ways of discouraging Christians. Some were burned alive at the stake. Others were nailed to a cross and left there until they died. Some Christians were fortunate and died a quick death. They were beheaded.

Not only were the Romans brutal to the Christians, but so were some Jewish leaders. They, too, did not like Christianity. They felt that Christianity was changing their religion. Many Christians were persecuted by the Jews. Even St. Paul was persecuted by the Jews. He tells how on five different occasions he was given thirty-nine lashes with a strap, three times he was beaten with rods, and once he was beaten with stones. He tells about his torture in 2 Corinthians 11:24-25.

Obviously, this was a very dangerous and threatening time for the Christians. The Apostles and the early Christians had to be very careful in teaching about Jesus and in establishing churches. It was necessary to do everything in secret.

A favorite secret meeting place of the Christians was the catacombs. These were very large underground cemeteries. The ancient people used the underground caves as places for burying their dead. Often times they carved out rocks to make a tomb for their loved ones. Some of these excavations were gigantic. In fact, some were so large that they included halls and large rooms. These rooms and halls were painted and decorated. The word catacomb comes from a Greek word *kata* and a Latin word *cumbere* which together means "next to the burial place." The Christians were burying the martyrs of Christ in the catacombs. The Christians would also gather there to pray. Thus, the catacombs were an ideal place for the early Christians of the city to meet and learn about Jesus.

The catacombs, especially those of Alexandria, Egypt and of Rome, Italy give much information about the life of the early Christians. In visiting the catacombs, one sees that the early Christians decorated the tombs with pictures of scenes from the Holy Bible and from the life of Christ. They also decorated the walls of the catacombs

with symbols. A popular symbol they used to represent the Cross of Jesus was the Greek letter T.

Another of the earliest symbols the Christians used was the fish. It may seem strange that a fish was used to teach about Jesus, but the fish symbol has many meanings. In ancient Greek, the word for fish is *icthys* which in Greek is spelled ΙΧΘΥΣ. These became an abbreviation for *Isous, Xristos, Theos, Yion, Soter*. This means "Jesus Christ, Son of God Savior." These are the words of a prayer that Christians say. The symbol of the fish teaches that Jesus is the Son of God. In addition, it helps people remember the short prayer which we still use today. This symbol also reminds us about the miracle of the five loaves of bread and the fishes. And finally, the symbol of the fish helped the Christians to recognize one another.

Another symbol which the early Christians used was a bird, the dove. In the story of the Baptism of Jesus in the Jordan River, the Holy Spirit came out of the heavens as a dove. Another secret meaning of the dove is found in the Old Testament story of Noah and the Great Flood. It was a dove that returned to Noah "with an olive branch in its beak" to let Noah know that the Great Flood was over. The dove was and is recognized as a symbol of peace.

Later, the Christians began to draw portraits of martyrs on the tombs. The portraits reminded the Christians of the martyrs. The Christians would pray near the tombs and pictures of the martyrs. Over time, other Christians painted these portraits on panels that could be placed in homes or in other places for prayer. These are the first icons.

These symbols and many more were used to teach about Jesus. The use of symbols helped Christians in many ways. First, the symbols which taught about Christianity, gave the people a feeling of safety. They felt the cruel rulers would not discover what they were doing. Moreover, these symbols allowed the Christians to safely recognize one another. Furthermore, those who could not read or write saw the symbols and understood their meanings. Even people who spoke different languages knew the stories the symbols told. And, finally, since only the Christians knew about the symbols, the people who were non-Christians, paid no attention to these signs.

❧ ❧ ❧

Two

THE FIRST ICONS

To understand and appreciate the Holy Icons, it is important to refer to the teachings of the Orthodox Church. The Orthodox Church receives her teachings from Holy Scripture and Holy Tradition. In the beginning, the teachings of Jesus and His Apostles were not written. The teachings were told orally from one generation to another generation. Later, the Apostles wrote about Jesus. Many of these writings were collected into the book we call the Holy Bible or Holy Scripture.

It was impossible though for the Bible to include everything about Jesus. The teachings of Jesus and His Apostles which are not in the Holy Scriptures are in the Holy Tradition. Over time, the Church collected more teachings about Jesus, the Virgin Mary, the saints, the Divine Liturgy, the sacraments, and other important issues. Many of these teachings were first decided at Ecumenical Councils, which were gatherings of the bishops of the Church held at various times in Church history. The Councils met to discuss and solve problems that faced the Church. These Councils also wrote rules for the Church called canons. The last Ecumenical Council was held in the year 787. Also, many things that Christians do are part of Holy Tradition. For example, Christians make the sign of the Cross. It is a very ancient practice, but no one is exactly certain how this practice began. These are all part of Holy Tradition.

Holy Tradition and Holy Scripture cannot be separated. To understand the Holy Scriptures, it is necessary to know the Holy Tradition. And, to appreciate and understand the Holy Tradition, it is important to know the Holy Scriptures

The stories of the first icons are found in Holy Tradition. The story of the first icon is that of Jesus. This story takes place when Jesus lived on earth. In a small country of Edessa, which was between

the Tigris and Euphrates Rivers, lived King Abgar. King Abgar suffered from a terrible disease called leprosy. The people who had leprosy were required to live away from healthy people. They had to live with others who had the same disease. These people were called lepers.

King Abgar had heard about Jesus and wanted to see Him. So Abgar sent his messenger, Ananias, to Jerusalem with a letter for Jesus. In the letter Abgar asked Jesus to come to Edessa. He wanted Jesus to heal him of this terrible sickness. Abgar told Ananias, who was also a painter, that if Jesus could not come, that he, Ananias, was to paint a picture of Christ. Ananias was to take the picture back to Edessa.

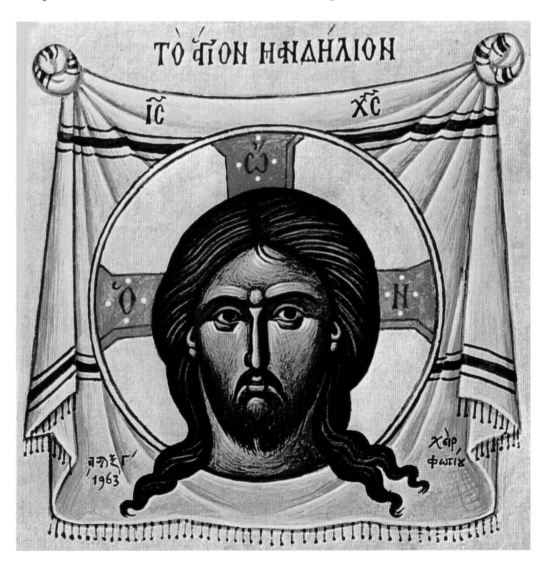

Ananias traveled the long journey to Jerusalem and finally found Jesus. But, when he found Jesus, there was a very large crowd of people around Him. Ananias could not get close to Jesus. There were many people in his way. He had a very difficult time trying to see Jesus. After trying to get through the crowd, Ananias climbed up on a rock so he could see Jesus. Now that he was able to see Jesus, Ananias began to sketch a picture of Christ. As hard as he tried, Ananias could not draw the picture of Jesus. He simply could not draw the face of God on paper.

Jesus saw that Ananias was having a difficult time trying to paint the picture. Jesus quietly asked for some water, washed His face, and wiped it with a piece of linen cloth. Christ's image remained fixed on the linen cloth.

Christ gave the linen cloth and a letter to Ananias for King Abgar. Christ was not able to go to Edessa. However, Jesus wrote Abgar that He would send one of His disciples to Edessa when His mission was finished.

Happily, Ananias returned to Edessa with the linen cloth and letter. When Abgar received the linen portrait of Christ, he was cured of the leprosy, but the scars remained. We know this linen portrait as "The Icon Not Made By Hands." After Pentecost, which is fifty days after our Lord's Resurrection, Thaddeus went to Edessa. Another name for Thaddeus is St. Jude. Thaddeus healed the scars on King Abgar's face, and converted him to Christianity. The country of Edessa was the first country to become Christian. This happened between 170 and 214 AD.

According to historians, the original icon was kept in a small chapel at the city gates of Edessa. On August 16, 951 the linen icon of Christ was taken to Constantinople. There was a reason that the icon left Edessa. The ruler of the Byzantine Empire, Emperor Romanus was very ill. He was not getting better, so he asked that the icon be brought to Constantinople. The icon was in Constantinople until 1204. It was in 1204 that the terrible Fourth Crusade plundered and destroyed much of Constantinople. "The Icon Not Made by Hands" and many, many other valuable items of the Church were stolen by the Crusaders and taken to Italy. No one knows where the original icon is or even if it exists.

Looking at the icon, notice that only the face of Christ is shown.

His face is outlined with His long, brown hair. Christ has a sad look on His face and His large eyes are sorrowful. Around the head of Christ is a halo which is also called a nimbus. In this halo is a cross with the Greek letters "OΩN" which means "He Who Is."

The Orthodox Church celebrates the day that the icon was moved from Edessa to Constantinople. It is known as "The Feast for the Transfer of the Icon of Christ from Edessa" and is celebrated on August 16. In a book called a menaion (the ancient Greek word for month), we can find the story about Abgar and the icon. The menaia is a set of twelve books – one for each month of the year. Included in the menaion are the stories of the saints and martyrs, the date their memory is celebrated in the Church, the holy days and the hymns for that month.

The second icon story from Holy Tradition is about the Mother of God, the Theotokos. Holy Tradition reveals a story about an icon of the Theotokos which was painted by St. Luke the Evangelist. St. Luke was very talented. In addition to being a painter, he was a physician. St. Paul referred to him as the "glorious physician." Also, St. Luke is remembered for writing two books of the Bible. These books are "The Gospel According to St. Luke" and "The Acts of the Apostles."

Holy Tradition relates a story that St. Luke, who is called "The First Iconographer," painted five icons of the Theotokos while she was still alive. These icons can be found in Greece, Syria, Cyprus, and Mt. Athos. These icons were painted after Pentecost. St. Luke traveled extensively spreading the teachings of Jesus. When he was visiting in Jerusalem, he gave one icon, which he had painted, to the Theotokos. It was an icon of the Theotokos and the Christ child.

In viewing the icon of Loving Kindness, notice that the faces of the Theotokos and the Christ child are turned toward the viewer. The Theotokos is holding the Christ child in a tender, loving way, just as any mother would hold her baby. She is holding Him tightly but the Theotokos has a sad expression on her face. The Theotokos knows that her Son will suffer great pain in His sacrifice.

The Christ Child is cuddling close to His mother and is putting His face close to hers. His feet are bare with the one hidden in His clothing. This icon is important for it shows His human feelings and His human nature.

The symbols on this icon are also important. In the icons of the Theotokos, three stars are shown on her garments. On this icon only

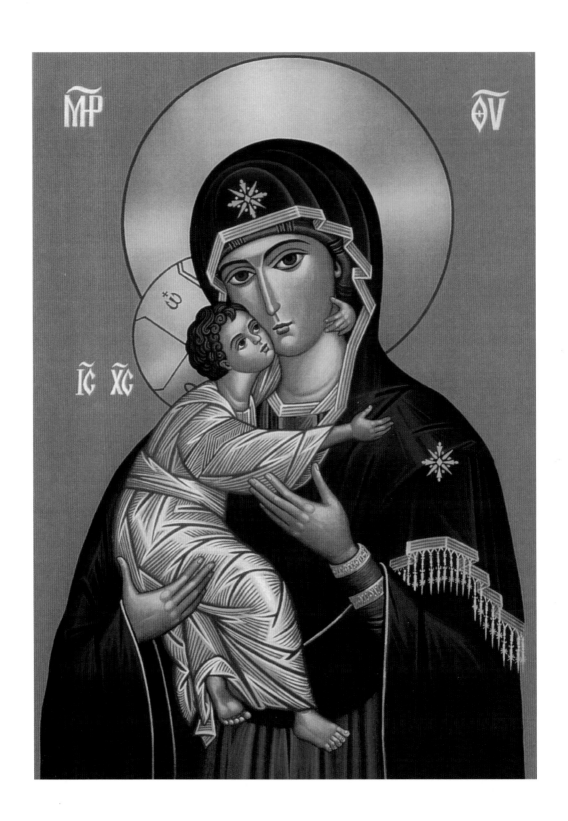

two stars are depicted. The third star is hidden by Christ. The three stars on the robes of the Theotokos teach that she was a virgin before, during, and after the birth of Christ.

The Greek letters MP ΘΥ, which are on either side of the halo of the Theotokos, are the abbreviation for *Meter Theou* which is Greek for Mother of God. The letters IC XC to the right of the Christ Child are the abbreviations for the Greek words *Isous Christos* which means Jesus Christ.

There are many icons which are said to have been painted by St. Luke. This does not mean that they were all painted by St. Luke. It simply means that these many icons were painted in the style in which St. Luke painted.

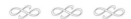

Three

THE FIGHT FOR ICONS

Christianity grew throughout the Roman Empire in spite of the terrible torture the Christians received. For three hundred years the Christians were persecuted. However, an event occurred in 312 AD which gave Christians the freedom to practice their faith in public.

The Roman Empire had been divided and generals were in a war to become the sole Emperor. Constantine was preparing to fight a very important battle. If he won, he would become the emperor. On the night before the battle, Constantine, who was a pagan, saw a vision in the sky. The vision was a Cross with these words around it: "In this sign conquer." Constantine was puzzled, but he ordered his men to paint crosses on their armor before going into battle. They obeyed his order. That morning, Constantine and his men won the battle and Constantine became the emperor of the Roman Empire.

Constantine knew that the Christians were being tortured and he remembered how the Cross had brought him victory. So, in 313 AD when Constantine was in the city of Milan, Italy, he gave an order. This order or edict gave religious freedom to all Christians.

Constantine was a good ruler. He cared for his empire. For many years Romans had discussed the idea of moving the capital of the empire from Rome. There were many reasons for wanting to move the capital city. People disliked living in the city because it was very old and dirty. Another reason was that the city was far from the sea and all the food had to be imported. Even some emperors who ruled the Roman Empire refused to live in the city of Rome.

So, Constantine carefully looked for a good place to move the capital city. He chose the ancient Greek city of Byzantium for the new capital. The small town of Byzantium was located in a very important place. It was at the end of a small peninsula where the Bosporus comes into the Sea of Marmara. This made it a very important place. It was on the easiest land route from Europe to Asia. It also provided the sea passage from the Mediterranean to the Black Sea. The harbors in the Bosporus and the Sea of Marmara were safe for ships during storms. In addition, the wooded hills around Byzantium had many springs for good drinking water. The soil around the city was rich and the people could raise many crops. Another good feature was that there was good pasture land for the sheep and the cattle. Most importantly, it was easy to defend from attackers.

Constantine rebuilt the city and called it New Rome. However, the people referred to it as Constantinople, which means "Constantine's City." It was here that the Roman Empire became powerful again. We often hear it called the Byzantine Empire, because it was founded on the city of Byzantium. This empire lasted for over 1000 years – from 329 AD until 1453 when the Empire was overrun by the Ottoman Turks.

Over many years, Constantinople, the capital of the Empire, became the most magnificent city in the world. Constantine encouraged immigration to his city. Because of this, a large number of noblemen, merchants and artisans from all parts of the empire moved to Constantinople. This was good for the city. The city was not only the center of government, but was the center for learning, the center for the arts, and the center for religion. It was the home of the patriarchs of the Church.

As the center of religion, Constantinople became the home of a patriarch for the Church. Ecumenical Councils were held in the city or nearby. Many holy objects were given to the emperors and the patriarchs. For example, a piece of the Cross of Christ, the column

where Christ was tied and whipped, and the Holy Shroud of Jesus were all found in Constantinople.

In addition, icons of Christ, His mother, and the saints were being painted in the city. They were placed in churches, monasteries, and homes to help people learn their Christian faith and their worship of God. Who painted these icons? Obviously, the work fell to artists and especially to those who knew the most about the religion — the monks and the priests.

The monks and priests were missionaries also. They went to foreign lands to preach about Jesus. These monks and priests did missionary work in the Balkan peninsula and Russia. As they went out into the world to teach about Christianity they also taught the people how to paint icons.

By the sixth century a style of painting icons appeared. We call it Byzantine. The center for this Byzantine painting was at the capital city of Constantinople. This style of painting had its beginnings in many sources, but the most important source was from the Church. The teachings of the Church (doctrines) instructed the painter, that is the iconographer, what he could paint and how it was to be painted.

As the art of the icons grew, unfortunately, there were some people in the empire who did not want icons. They objected to having images in the church. Those who did not want icons were called "iconoclasts." It means icon-smashers. There were several reasons why the iconoclasts wanted to get rid of the icons.

The iconoclasts believed that kissing an icon was worshipping it and the Ten Commandments said that people should not worship idols, like the pagans. They believed that some people venerated the image and not the person represented on the icon. Another example of misunderstanding was that some people thought they could be saved if they just paid for icons to decorate the churches.

There were also examples of abuse of the icons by those who loved icons. For instance, some priests scraped the paint off the icons and mixed it with the Holy Communion. Still yet, some priests celebrated the Divine Liturgy on an icon instead of at the altar. And another abuse was that often the icon was used as a godfather or a godmother at a baptism. The iconoclasts wanted these abuses stopped. An argument about images in the Church was growing.

In addition to the controversy going on within the Church, there were outside forces adding to the problem. Parts of the empire were

being attacked and taken over by Moslems. In Islam, there are no images allowed. In the seventh century, the Moslem Arabs had conquered Syria and Palestine. In the beginning, the Moslems allowed the Christians to have icons, but that soon changed. In 723 AD, Khalif Yazid gave an order to remove all icons from all the Christian Churches in Syria and Palestine.

Not only were the Christians affected with the rise of Islam, but also the Jews. In the first century of Christianity the Jews were decorating their synagogues with images. Now they were frightened by the actions of the Moslems. The Jews returned to the teachings of the Ten Commandments. This prohibited the creation and worship of idols and the decoration of the synagogues with images. So, the Jews destroyed all the images in the synagogues. The Jews along with the Moslems discouraged the use of icons by the Christians.

Instead of improving, the situation was worsening. In 725, the emperor of the Byzantine Empire, Leo III, was greatly influenced by people who did not want icons. In this groups were not only Moslems and Jews, but also Christians. Leo preached a series of sermons against "the image worshippers." Even though the emperor was against the icons, there were still many people who wanted them. Finally, in 726 the emperor did something that outraged the people. He ordered the removal of a large icon of Christ which hung on the Bronze Gate to the city of Constantinople.

This act caused a huge riot. People demonstrated and killed the persons taking down the icon. The people demonstrated and revolted, but this did not bother Leo. In fact, in 730 he ordered the destruction of all icons. Furthermore, he ordered the arrest and punishment of all those who disobeyed his order. The churches and the monasteries were ordered to destroy all the icons.

The monasteries suffered the most. The monasteries had many old and beautiful icons. They believed that icons were proof that Jesus was human and divine. The monks defended the practice of painting and using icons in worship. One of them, John of Damascus, wrote a now famous book in defense of the icons.

The authorities were very cruel to the monks who defended the icons. They killed some monks by drowning them. Some authorities bashed the heads of monks with icons until they died. The monks who were the iconographers, that is the painters, had their hands severely burned. Now the new law was to destroy all icons. The monks

and priests were devastated. They could not bring themselves to destroy the icons. It is reported that many monks, in order to save the icons, hid them under their robes and fled from Constantinople. These monks and priests went to Greece, others fled to Italy, and others went into the hills of Cappadocia in order to save the icons.

Not only did the monks suffer persecution, but the people who wanted icons suffered much punishment by the iconoclasts. In the annals of Church history is the story of the torment which Sts. Theophanes and Theodore suffered. The Patriarch of Jerusalem had asked them to preach sermons in favor of icons which they did. However, a group of iconoclasts did not like what they were doing or saying. Theophanes and Theodore were captured by a mob and were severely beaten. The mob continued the torture of these two brave men. The leaders of the mob branded an insulting word on the faces of Theophanes and Theodore. Theophanes eventually became a Metropolitan of Nicaea, a city not too far from Constantinople. The Church venerates these two saints and remembers the torture they suffered. They are referred to as the "marked" saints.

In 780, a new empress took the throne. Her name was Irene. She loved the icons and ordered that a Council be held to decide the matter. The Council was held in Nicaea in 787. The bishops and priests who attended these councils were from ancient sees or cities of the Church — Constantinople, Antioch, Jerusalem, Antioch, and Alexandria. No one from Rome was able to attend. The Council used the arguments contained in John of Damascus' book to defeat the arguments of the iconoclasts. The Council accepted the use of icons in the Church and in worship. It proclaimed that respect and reverence are paid to Christ and the saints which are shown on the icon and not to the icon itself. The Council said that the icons are venerated but they are not worshipped. The Council decided icons were like the Holy Scriptures and worthy of honor and veneration.

You would think that the controversy was over. However there were still those who disagreed with the Council. For another fifty years the argument continued. The last emperor of the iconoclast period was Theophilos. He was against the icons, but his wife, Empress Theodora, was a very devout person. She wanted the icons returned to the Churches. It is said that she had a secret closet where she kept her many icons. She would go to her secret hideaway and kneel in prayer before her icons. Theodora truly believed that icons would be

returned to the churches. When Theophilos died, his son, Michael III, was still a child. His mother, Theodora, declared herself his regent. That is, she became the ruler for her son until he reached adulthood.

Once she became the regent, she called a Council to decide the matter once and for all. The Council was held in 843 and reached a very important decision. This Council agreed with the Council of 787 and accepted the use of icons in the Church and in Orthodox worship. On the first Sunday of Lent, the people were called to bring their icons out of hiding and restore them to the churches. The Orthodox Church considered the restoration of the icons of such great importance that it named the first Sunday of Lent as "The Sunday of Orthodoxy" or "The Triumph of Orthodoxy."

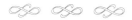

Four

WHAT IS AN ICON?

The iconoclast controversy was over but many people had questions about the icons. They were asking: What makes an icon an icon? How is an icon painted? What is included on an icon? Who has authority over the icon?

The Seventh Ecumenical Council is the most important Council which discussed the icons This Council gave instructions about the icons. It did not give specific directions as to how the icon should be painted, but it did give the basic idea of what makes a true icon. The Council said that everything on an icon should be different from the materialistic or real world. The icon, they declared, had to be a form that would carry the viewer from the earthly world to the heavenly kingdom of God. One canon instructed that beautiful women and handsome men could not be used as models, like portraits.

Another question the Councils had to decide was: What is the difference between what is an icon and what is a portrait? After much discussion they finally defined a portrait as an image of an ordinary human being. An icon is an image of a man or woman who is united with God. In addition, the fathers of the Church said that Christ should

be painted as God-man. The Theotokos is painted in a way that shows her holiness. These instructions from the Councils also apply to all the images of saints, martyrs, and holy people shown on the icons.

There are other characteristics which define a Holy Icon. It is important to note, that rarely are the profiles of the images ever shown on an icon. The reason for this is that the full face of the image shows that the saint is in prayer before the face of God. While the saint is in prayer before God, there is, at the same time, a direct communication between the saint and the viewer.

Other features which are associated with the Holy Icons are the exaggerated organs of the five senses. The Church fathers said that the five senses — smelling, seeing, hearing, feeling, or touching and tasting — are the doors to a person's soul. Since these senses have been made holy by God they ceased to be only normal sensory organs. Therefore, on the icons the organs of the five senses are not anatomically correct.

On the icons, the eyes are large and this is because they have seen great things. The ears are large and wide for they have heard the commandments of the Lord. The nose, which smelled the fragrance of the Holy Trinity, is drawn long and thin. Moreover, the small mouth on the saint, indicates that the saint obeyed the Lord. Also the saint needed the least amount of food to exist.

The five senses are not the only part of the anatomy which are drawn incorrectly. The blessing hand and the fingers are drawn extraordinarily large to show how important is the act of blessing. Sometimes the saint's head is not in the proper proportion to the body. This allows the face of the saint to be seen more clearly as the face is the expressive part of the image. Often the body of the holy person is made longer than normal. The reason for this is to teach that the holy person has been transfigured by the Holy Spirit and is "not of this world."

Another feature of icons is that there are no shadows on the icons. In Orthodox iconography the crown of light, known as the halo or nimbus, illustrates the holiness of the person. However, in Orthodox art, it is not always necessary for the head of the saint be surrounded by a halo. The holiness of the person is indicated in the whole person. The saintliness or the holiness of the person shines out from the entire body. The light of God saturates all things, therefore, the images on the icons do not cast shadows.

The fathers of the Councils also passed canons or rules which give the iconographer instructions as to how to draw the garments on the icons. The clothes are not to show the natural body line of the saint. Instead, the rules told the iconographer to use simple lines and wide overlaps of the garments. This is to show the spiritual body and not the natural body of the saint. Even though the canon instructed the iconographer to show the spiritual body of the holy person, the iconographer was told that the garment must show the saint's profession. That is, was the saint a man or a woman, a prince, a soldier, or a priest.

In addition to the style of the garments, the canons indicate which colors are to be used for the garments of Christ, the Theotokos, saints and other holy persons. The color gold is reserved for Christ. In addition, red, blue, and green are also reserved for Jesus and the Theotokos. The colors of white, gray, lighter shades of red, blue and green are used for other holy persons.

In Orthodox iconography, the scenery and the background are not of great importance. The saint or the event shown on the icon is the important lesson. Therefore, not much background or scenery is shown on the icons. Only the most necessary items are used to tell the story. If servants or attendants are included in the icon, they are usually shown much smaller than normal. The animals such as the horses and oxen are usually shown as small animals. In fact, the horse is shown as the size of a colt and the oxen as calves.

When a building is included in the icon, only the barest part of the structure is drawn. A single door is symbolic of an entire building. An entire church is not drawn. Only the roof and a dome are drawn to indicate a church. Often windows and roofs are purposely not drawn correctly. This is to teach the faithful that the action represented on the icon is as difficult to understand as is the incorrect architecture.

Painting an icon is an important and sacred duty. Not everyone is entitled to be an iconographer. Just because a person is a talented painter does not necessarily mean that he can be an iconographer. There are important tasks an iconographer should do before beginning to paint an icon.

The fathers of the Church Councils, in their wisdom, gave specific instructions to the iconographer in preparing to paint an icon. First, the iconographer must be a person of high, moral character and must participate in the religious life of the Church. Before painting

an icon, the iconographer must fast, pray, partake of the sacrament of Confession and receive Holy Communion. After the icon is finished, the iconographer does not sign the icon. If the icon is signed, the phrase "Through the hand of" is added. The iconographer believes that God painted the icon and that he merely assisted God.

Furthermore, the actual painting of the icon is an involved process. In fact, the process has been handed down from generation to generation and traces its beginnings back to the artists of ancient Greece. The icon can be created in many ways. A fresco is made when the image is painted on wet plaster on a wall. In a mosaic, hundreds or thousands of tiny stones or tiles are used to make the icon. An icon can be carved in wood. Of course, they also can be painted on wood or on canvas. Icons are traditionally painted with a paint made from egg yolks to which colors are added. The process is highly technical and requires great skill.

There are many important steps in painting an icon. Some of these steps include preparing the wooden panel, gluing a piece of linen to the wood, adding many thin coats of liquid to the linen, and finally beginning the painting of the icon. The painting is an involved process.

After the icon is finished and has dried, the iconographer has one more important step. That step is applying several coats of linseed oil to the icon. This process protects the icon from pollution of light and smoke. The iconographer must be very experienced in this last operation or the icon could be ruined.

Finally, an icon must be blessed by the priest. The Seventh Ecumenical Council said that it was not necessary to bless the icons. The reason they gave was that the represented image is already blessed. Unfortunately, times are not the same as they were where when the Council passed this canon. In today's modern world, almost everything — including icons — is mass produced. We do not know if the icon was mass produced, who made it, or under what conditions it was made. Therefore all icons should be blessed by a priest.

The fathers of the Councils instructed that the art belongs to the painter, but the order of the content of the icons belongs to the Church. In other words, the iconographer who has the God-given talent to paint will deal with the technical part of painting the icon. The Church, however, has the authority over the art and the artist as to what can be painted and how the icon is to be painted.

Part Two

THE ICON AND ITS STORY

In the following pages, the stories of the Great Feasts of the Church will be told through the icons. You will see that certain parts of these Feasts are in the Holy Bible, but some are not. All feasts have elements that are in the Holy Tradition and in Holy Scripture. The Church has Pascha and twelve other Great Feasts that celebrate events in the lives of our Savior Jesus and His mother the Virgin Mary the Theotokos.

Pascha is the most important feast of the Christian year. Pascha is also called Easter. It is known as the Feast of Feasts, the greatest of the feasts of the Church.

The Feasts for the Theotokos are:
The Nativity of the Theotokos celebrated on September 8
The Entry of the Theotokos to the Temple celebrated on November 21
The Annunciation celebrated on March 25
The Dormition of the Theotokos celebrated on August 15

The Feasts of the Lord are:
Elevation of the Holy Cross celebrated on September 14
The Nativity of Christ celebrated on December 25
Theophany celebrated on January 6
Presentation of Christ in the Temple celebrated on February 2
Palm Sunday celebrated one week before Easter
Ascension Thursday celebrated 40 days after Easter
and always on a Thursday
Pentecost Sunday celebrated 50 days after Easter
and always on a Sunday
Transfiguration celebrated on August 6

THE NATIVITY OF THE THEOTOKOS

September 8

Some stories which the Holy Icons tell are not found in the Holy Scriptures. These stories are part of our Holy Tradition. The Church fathers said that everything could not be written in the Holy Scriptures. Therefore, the stories not in the Holy Scriptures are in Holy Tradition. For example, many of the events in the life of the Virgin Mary are part of the Holy Tradition. One book, the *Protevangelion of James*, contains many of the stories about the Virgin Mary, her parents Joachim and Anna, and their family. The *Protevangelion of James* is not as important a book as the Gospels, but the Church fathers accepted some of the stories as being important.

Mary's parents were a very devout couple. Her father, Joachim, was from Galilee and Nazareth and her mother, Anna, was from Nazareth. They had been married for almost twenty years, but had no children. This bothered them. They felt sad that they had no children. In those days, the people of Israel believed that if a couple didn't have children, the couple was being punished by God. Joachim and Anna never complained, but they prayed to the Lord that they would have a child some day.

One year, Joachim and Anna went to Jerusalem to celebrate the Jewish holiday, the Feast of Dedication. The High Priest of the Temple was Issacher. He was not a good man. When the High Priest saw Joachim in the Temple, Issacher began to insult Joachim for not having children. He made fun of Joachim in front of all the people in the Temple.

Joachim was hurt, embarrassed, and humiliated. He did not know what to do. He was so devastated that he wanted to be alone. He

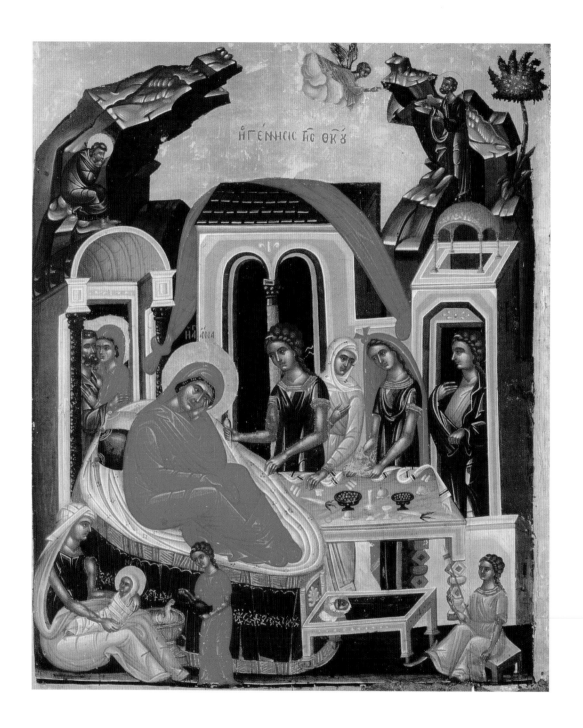

went alone to the mountains. He stayed with some shepherds who were in the mountains with their sheep. Anna, too, was upset. She had been insulted and now her husband was so upset that he went off to the desolate mountains. She was worried about him. So, Anna went back home and spent her days praying to the Lord.

After some time had passed, an angel appeared to them. First the angel went to Joachim and then he went to Anna. The angel gave each the same message. They were told that Anna would bear a daughter and they should name her Mary. Furthermore, they were instructed that when the child reached the proper age, they were to take her to the Temple. In addition, they were also informed that while Mary was still a virgin, she would give birth to the Son of God.

The angel also gave Joachim and Anna a sign. They were to meet at the Golden Gate of Jerusalem. The distraught Joachim went to the gate and met his wife. Both were happy and praised the Lord. They eventually had a baby and named her Mary according to the angel's instructions.

The story is told in the icon of "The Nativity of the Theotokos." The attention of the viewer is directed to St. Anna and the child who has just been born. St. Anna is shown lying on the bed. She is surrounded by some servants. Some are tending her needs. Others are preparing to wash the newborn infant Mary. The story makes clear that Mary was selected by God.

Mary is in swaddling clothes, which is a garment that wraps tightly around a baby. The midwife with the attendant, who are not the main characters, are shown as small people. A midwife is a woman who helps a mother during childbirth. Anna is looking downward toward her newborn child. Mary is held by the midwife.

The action in the lower part of the icon contains two scenes. The one scene shows the attendant preparing to bathe Mary. In the other scene the servant is watching over her in the cradle. It is a very realistic scene. Did you see that one foot of the attendant is on the rocker of the cradle?

In the upper right hand corner of the icon is a sad Joachim. He had been humiliated and went off by himself into the mountains with the shepherds. The sharp angles of the rock formations indicate the harshness and the wildness of this desolate area. In the upper left hand corner of the icon Joachim is standing and receiving the message from the angel.

To the left and towards the middle of the icon are two figures. They are Joachim and Anna who met at the Golden Gate after they had received the message from the angel. They are outside. The red drape which is tied to one column indicates that the action of the main scene is taking place indoors.

*T*HE *E*NTRY OF THE *T*HEOTOKOS INTO THE *T*EMPLE

November 21

The story of the entry of the Theotokos into the Temple is found in the book of the *Protevangelion of James*. The Orthodox Church celebrates this event on November 21.

Mary's parents, Joachim and Anna, were very religious. They had promised that they would dedicate their child to God. The custom, at that time, was that all children who were dedicated to God, were taken to the Temple when they were three years old. There they were taught and cared for by the holy men and women of the Temple. These children stayed in the Temple for twelve years where they received an excellent education. Many young virgins and aged widows lived in the Temple. These widows had dedicated their lives to the service of the Lord. They studied the Word of God and taught others.

When Mary was three years old, Joachim and Anna took their daughter to the Temple. She was to be separated from her parents. To prepare Mary for her trip to the Temple, her father, Joachim called the young girls of the neighborhood together. He gave each one a lighted candle and had them walk in front of Mary. The three year old Mary was so excited to see the candles that she followed them to the Temple. Not once did she look back to her parents, nor did she cry when she left her parents. Her parents wanted her to go happily to the Temple.

When they arrived at the Temple, the High Priest Zacharias greeted Mary. Zacharias took Mary into the Temple and into the Holy of Holies. The Holy of Holies was a very special place of the Temple. Only Zacharias, the High Priest, had the right to enter the Holy of Holies and he could only do this once a year. The High Priest Zacharias took Mary into the Holy of Holies, because he, like other prophets,

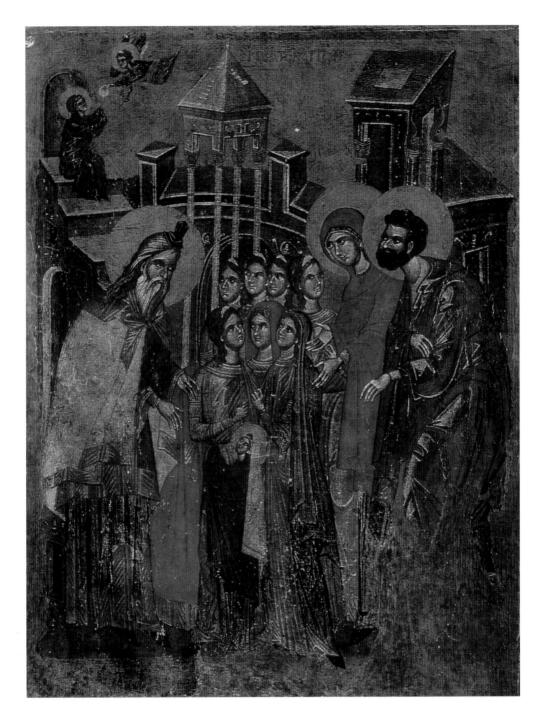

understood what God had planned for His people. Zacharias knew that Mary was to become the Mother of Jesus, our Savior.

The icon tells the story of Mary's entry into the Temple. The High Priest Zacharias, in his priestly robes, is standing on the step of the Temple greeting the young child. Mary, is painted as a small child. She is standing before Zacharias with her arms reaching up to him.

The young girls who escorted her to the Temple are behind her. Joachim and Anna are presenting their child to Zacharias.

At the upper left of the Holy Icon, Mary, the Theotokos is sitting on the highest step. This indicates the Holy of Holies. An angel is there to assist her.

This story of Mary's entry to the Temple shows her dedication and devotion to God. In addition, it shows that she is willing to accept the awesome task as the Mother of our Lord. From this icon we understand that God was with her from a very early time of her life.

The Annunciation of the Theotokos

March 25

The icon of The Feast of the Annunciation is one of the oldest icons of the Church. An image of the Annunciation can be found in one of the Roman catacombs, from the beginnings of Christianity. The details of the icon have remained about the same since that time. The only detail that has changed is that in the image in the catacomb, the Archangel is shown without wings.

The story of the Annunciation is found in the Holy Scriptures and is told in Luke 1:26-28. The Archangel Gabriel appeared to Mary. He said, "Rejoice! Mary, full of grace; the Lord is with you; blessed are you among women."

Mary, obviously, was frightened. She did not know what to do or what to say. Mary was bewildered and confused. She was troubled by this greeting. But the Archangel Gabriel told her not to be afraid. He told Mary that she would have a son and she was to name Him Jesus.

Mary had more questions and the Archangel said that the Holy Spirit would descend upon her. The Archangel Gabriel also told her that her cousin Elizabeth would also have a son. Mary believed the Archangel and told him, "Behold, the servant of the Lord; let it be unto me according to your word." She accepted what the Lord offered her and the Archangel departed.

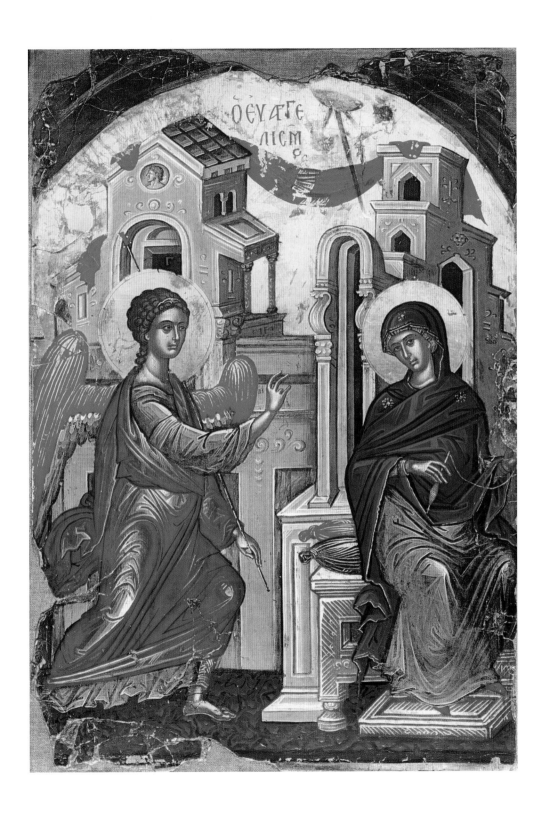

The icon of the Annunciation is a joyous icon. The bright colors of the icon show this joy and happiness. The Archangel has just descended from heaven and has something important to say. The Archangel is shown with his feet wide apart as though he is running toward Mary. In his left hand is a staff which is the symbol of a messenger. The fact that his one wing is raised also shows that he is a messenger. The Archangel's right hand is extended towards the Theotokos and he gives her the good news from His Master.

In this icon, the Theotokos is seated and has a spindle of yarn in her hands. This detail is from Holy Tradition. In some icons she has dropped the spindle because she is so surprised by the appearance of the angel and his news. The head of the Theotokos is turned towards the Archangel and this shows that she is listening to him. On her clothing are three stars indicating that she is a Virgin before, during, and after the birth of Christ.

In the upper part of the icon is a semicircle which is a symbol of heaven. Rays are coming from the sphere and are directed to the Theotokos. Thus, the action of the Holy Spirit is demonstrated.

The action of the Annunciation takes place in a room. The red drape hung across the structure in the background signifies this. The strange and unbelievable architecture helps the viewer understand the incomprehensible event which is taking place. As unbelievable is the architecture, so is the event.

The Annunciation is very important. The Theotokos willingly said yes to God's news that she would give birth to His Son. She could have refused, but she did not. She accepted the will of God and she did this consciously and with deliberation. Because the Theotokos said yes, all the people of the world have a chance to be saved.

THE DORMITION OF THE THEOTOKOS

August 15

The Feast of the Dormition of the Theotokos is based mostly on

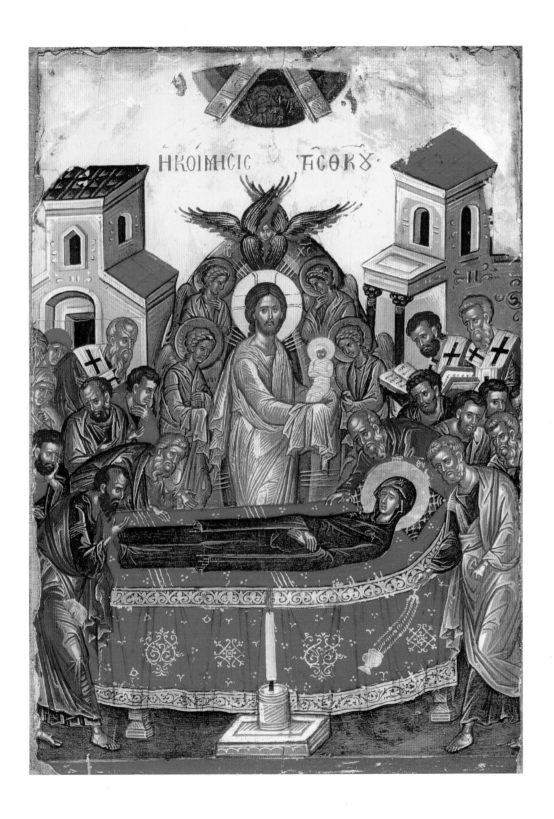

43

Holy Tradition. This feast, one of the Twelve Great Feasts is celebrated on August 15. Dormition means "falling asleep" from the Latin word, *dormire*. Orthodox Christians believe that when people die, they have "fallen asleep," which means that they will awaken when Jesus comes again.

According to Holy Tradition, the Apostles followed the instructions which Jesus gave them at His Ascension. They went to many lands in order to preach and teach about Jesus. However, the Theotokos remained in Jerusalem and made her home with John. John was the beloved disciple of Jesus and Jesus had instructed John to take care of the Theotokos. During her life, the Theotokos also preached and taught the Word of God.

After many years, the Theotokos had grown old and knew that her death was near. She wanted to see the Apostles once more before she died. Miraculously, all the Apostles, except Thomas, were carried by a cloud to Jerusalem. The Apostles along with St. Paul, Bishop Dionysios the Areopagite, Bishop Hierotheos, and Bishop Timothy were at her bedside. They were all present with the Theotokos when the time came for her to join her Son in heaven. Suddenly, a bright ray of light shone, and Jesus appeared before the group. He took the soul of the Theotokos into heaven.

Before her death, the Theotokos showed the Apostles where she wanted to be buried. She had selected a cave in the Garden of Gethsemane as her burial place. The Apostles fulfilled her wishes and she was taken to that spot. Her funeral procession was followed by a large crowd. St. Peter led the large crowd to the Garden of Gethsemane.

Jewish leaders and priests, who did not like the Christians, tried to break up the funeral procession. One Jewish priest, Athonius, tried to overturn the bier (coffin). His hands were cut off by an invisible angel. However, Athonius repented and the apostle Peter healed him.

The Apostle Thomas was not able to attend the funeral. He arrived three days later and was very upset and sad. He, too, wanted to see the Theotokos one last time. The other Apostles took him to the tomb, opened it, but the tomb was empty. An angel of the Lord appeared to them. They were startled, but the angel told them that the Theotokos had been taken into heaven.

The icon of the Dormition of the Theotokos shows the Theotokos lying on her deathbed and surrounded by the Apostles. Christ is standing in the center of the icon looking at His mother. In His hands, He

holds a small child clothed in white. This small child represents the soul of the Theotokos. Note the halo around her head. Around Christ is a group of angels which form the outer border around the mandorla of Christ. A mandorla is a round area which has an image of a holy person inside. Above Christ is the six-winged Seraphim.

The three bishops stand to the left and right of Christ. They are Bishops Dionysius the Areopagite, Hierotheos, and Timothy. To the left of the icon are pictured some women and they represent the faithful people of Jerusalem. St. Peter is standing at the head of the Theotokos and St. Paul is at her feet.

Orthodox Christians believe that the Theotokos was taken bodily into heaven because when the Apostles took Thomas to the tomb it was empty. But, the Church has not officially accepted this belief. The Roman Catholic Church accepted this belief about one century ago.

The Orthodox Tradition, while not insisting on the literal truth of every detail in the account of the Dormition, is very clear on the main point. The Theotokos underwent, as did her Son, physical death. Her body and soul were taken up into heaven. The "Icon of the Dormition" represents a picture of Christian death. We find salvation in Jesus Christ Who raises all who believe in Him.

THE NATIVITY OF JESUS

December 25

The Feast of the Nativity of Jesus is one of the most joyful days of the Orthodox Church. It ranks next to the greatest holiday which is the Resurrection of Jesus on Easter Sunday. The Feast of the Birth of Jesus is also known as the "Incarnation of Christ." This means that Jesus became a man and came into the world to save us. We also refer to this joyous feast as Christmas.

The story of the Nativity of Christ is beautifully told in the Holy Scriptures. This story is told in two places of the Holy Scriptures. The story is found in Matthew 1:18-25 and in Luke 2:1-20, No matter how often the Birth of Jesus is told, we realize that it is an important event.

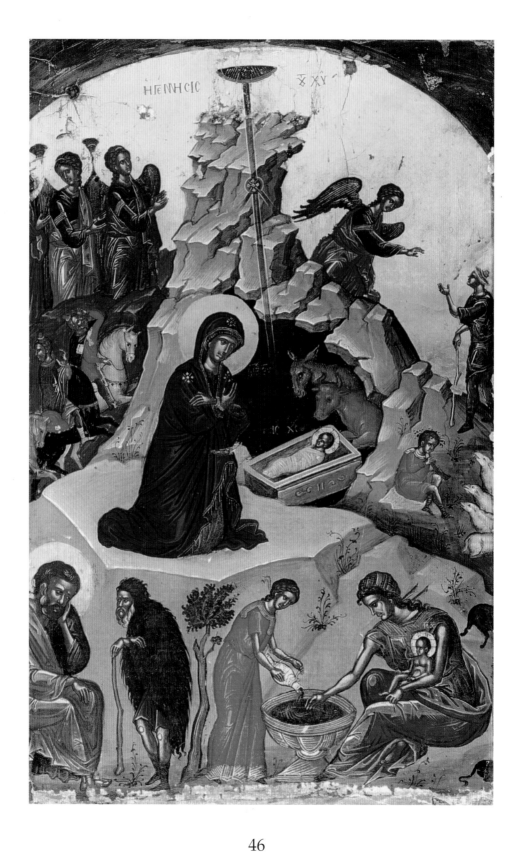

We are struck with wonderment of God's love for us. God sent his Son to save us from our sins and teach us how God wants us to live.

As the story is told by the Apostles, the Roman Empire was powerful. The Romans had conquered much of the then known world. Judea and Samaria, what we know today as Israel, were included in their conquests. Emperor Augustus ordered that a census be taken in all his lands. He needed to know how many people lived in the empire so he could tax them.

Everyone had to go to the town of their family's origin to register for the census. This meant that Mary and Joseph had to go to Bethlehem. They were descendants of King David and Bethlehem was the City of David.

Mary and Joseph lived in Nazareth and it was a great distance from Bethlehem. It was about 100 miles over very rugged roads. Moreover, Mary was expecting the baby and it was almost time for her to give birth. Bethlehem was a small town and there were many descendants of David who had come to register for the census. By the time Mary and Joseph arrived in Bethlehem there was no place for them to stay.

Joseph tried very hard to find a place to sleep that evening. There was no room at the inn. Finally, Joseph found a cave-like place where they could rest. This place was used by shepherds to protect their sheep in stormy weather. It was here that Mary gave birth to Jesus. The baby was wrapped in swaddling clothes and laid in the straw in the manger.

Now, that night the shepherds were out in the fields guarding their sheep. Suddenly, there was a bright light which startled the shepherds. The light was so bright that it turned the night into daylight. Of course, the shepherds were frightened. Nothing such as this had ever happened. Soon an angel appeared and calmed them. The angel said, "Fear not for behold, I bring you good tidings of great joy, which shall be to all people. For unto you is born this day in the city of David a Savior; which is Christ the Lord. And this shall be a sign unto you: You shall find the babe wrapped in swaddling clothes, lying in a manger" (Luke 2:11-12).

Then a larger group of angels appeared. They praised and glorified God and sang, "Glory to God in the highest, and on earth peace, and good will toward men" (Luke 2:14). When the angels finished singing, they disappeared and the light began to fade. It became dim-

mer and dimmer until it was dark again.

The shepherds were awed. They didn't know what to do. Finally, they decided to leave their flocks of sheep and go to Bethlehem. They decided that they wanted to see for themselves what the angels had told them. When they got to Bethlehem, they found Mary, Joseph, and the infant Jesus. They fell to their knees and adored Jesus.

Some Wise Men came from the East for they knew of the coming of Jesus. They had seen a star that told them that a new king had been born to the Jews. They followed the star and were looking for the child.

At this time the governor of Judea was King Herod. He was a wicked man and was feared and hated by the people. When Herod heard about the Wise Men looking for the child, he invited them to his palace. Herod asked the Wise Men to find the child so that he, too, could worship Him. But Herod was lying. He did not want anyone to take his place.

The Wise Men went on to look for Jesus. The Star led them to Jesus and Mary. When the Wise Men found Jesus, they fell to their knees and worshipped Him. They gave Jesus gifts of gold, frankincense, and myrrh. The Wise Men left but did not return to Herod. They had a dream that warned them that Herod wanted to harm Jesus. Instead, they returned to their native country by a different route.

The icon of the Nativity tells the story of Christ's birth from the Scriptures. It also shows that all creation is taking part in Christ's birth. The angels give thanks with their song; the heavens give the star; the Wise Men give their gifts of gold, frankincense, and myrrh. The poor, humble shepherds give their praise and amazement; the earth gives the cave, and humanity gives the Virgin.

This Holy Icon is an icon with many scenes. First, it stresses the importance of the Theotokos. She is placed in the center and is the largest figure in the icon. In this icon, she is kneeling with crossed arms, looking at the Christ child. The three stars, denoting her virginity before, during, and after the Nativity, are on her garments.

The Christ Child, in the center of the icon, is in swaddling clothes and is lying in the manger. In the background is the dark cave where He was born. In the cave are an ox and a donkey guarding the newborn Babe. Even though the Gospels say nothing of the cave, this information is from Holy Tradition. Neither do the Gospels speak of

the ox and the donkey, but all icons of the Nativity include these animals. Including the animals in the icon fulfills the prophecy of Isaiah 1:3, "The ox knows his master, and the donkey his master's crib; but Israel does not know me, and the people have not regarded me."

The long ray of light from the star points directly to the cave. This ray comes from the star and travels to all parts of the world. It teaches that this bright star is an astronomical happening, and is a messenger from heaven announcing the birth of Jesus.

On the right hand side of the icon is another scene. The Wise Men, who were led by the star, are riding horses to bring their gifts of gold, frankincense, and myrrh to Jesus. The Wise Men are of various ages. One is without a beard. In those days, young men did not wear beards. The other Wise Man has long hair and a long beard, which indicates that he is much older. These details teach that regardless of age and appearance, the Good News was given to each and everyone.

Opposite the Wise Men is the scene with the humble shepherds. An angel proclaims the glad tidings. A young shepherd plays a reed instrument. This scene reveals that the music of the humans was added to the hymn of the angels.

Across from the shepherd's scene is the heavenly choir of angels. They are giving glory to God. The angels serve two purposes in the Nativity of Christ. They give glory to God and announce the good news to all mankind.

The background shows a very rugged terrain. This is not a true representation of the land in this area. Joseph could not find room in Bethlehem, so they went outside of Bethlehem to a cave. This rocky mountain formation only serves as a background for the event.

In the lower part of the icon are two more scenes. In the left hand corner are the two women Joseph brought to take care of the Christ child. They are bathing Him just as any baby is bathed. The humanity of Jesus is clearly shown in this setting.

Opposite the bathing of Jesus scene sits a sad and worried Joseph. He is not part of the central group – the Christ Child and the Theotokos. Joseph is not the natural father. Joseph is troubled and despondent. There is an old man talking to Joseph. The old man is Satan. Satan can appear in many forms. Here he is as an old man who is tempting Joseph and disturbing him. Satan is telling Joseph that

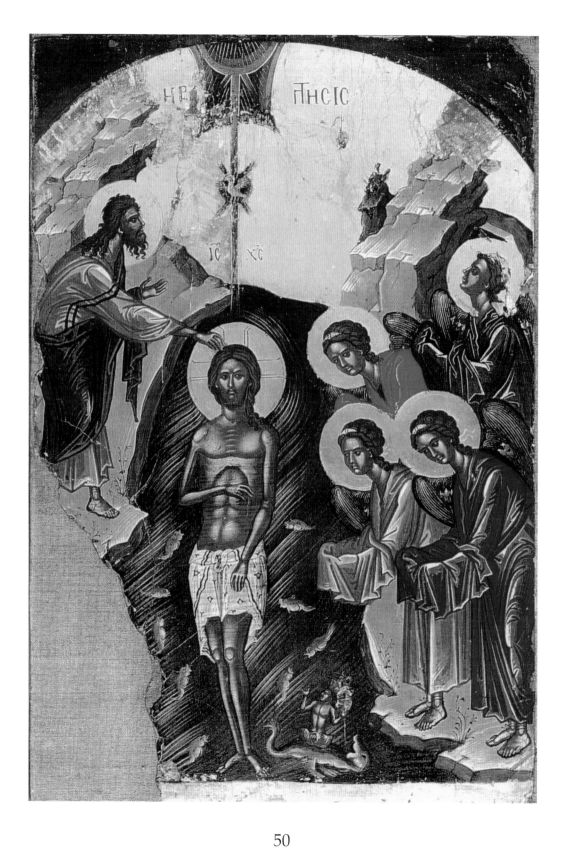

virgin birth is impossible. He's telling Joseph that he's a fool if he believes this. This story comes to us from Holy Tradition. The sad Joseph shows us not only his personal predicament, but the dilemma of all mankind — the difficulty of accepting that which is "beyond words or reason."

The tree, which is in the middle of the lower part of the icon, is a symbol of the Tree of Jesse. This tree refers to Isaiah 1:1-2, "But a shoot shall sprout from the stump of Jesse, and from his roots a bud shall blossom. The spirit of the Lord shall rest upon Him." King David was often mentioned as the son of Jesse and Jesus was from the House of David.

The Holy Icon of the Nativity reminds one to praise and glorify the Birth of Christ. The celebration of Christmas each years serves to remind each and everyone of us that Christ came for us – you and me.

THE THEOPHANY OF OUR LORD

January 6

The Feast of Theophany is one of the twelve important feast days of the Orthodox Church. This day is known also by other names. It is called The Baptism of Christ, Epiphany, or The Manifestation of the Holy Spirit. Whatever named is used, the Feast is celebrated on January 6.

The title of this major feast "Theophany" means "the appearance of God." This feast, which is one of the greatest days in the Christian year, is as important as Christmas and Pascha. In the Tradition of the Orthodox Church, Theophany celebrates our Lord's baptism in the Jordan River. In the Roman Catholic and Protestant Churches, this feast celebrates the adoration of the Wise Men.

The baptism of the Lord is told in the Holy Scriptures. In the Gospel of Matthew, chapter 3:1-17, the story of John and Jesus is told. John, who was a cousin of Jesus, is often called the "Forerunner" be-

cause he came before Jesus. He told the people about the Messiah who was to come. John is also called "John the Baptist," because he baptized people for forgiveness of their sins.

When John was quite young, he went into the wilderness where he lived alone. His dress was quite different. He dressed the same way that the old prophets dressed a long time before him. They wore robes made from camel's hair. The material was rough and not comfortable to wear. This was the type of clothing John wore. The food John ate was very simple. He lived on wild roots, locusts, and honey. John spent his time praying and preparing himself to do God's work.

Eventually, John left the wilderness and began preaching to the people. The main place where he preached was on the banks of the Jordan River. Many people passed by this area as they traveled from one place to another. John preached to them. His main theme was "Repent." Many stopped and listened to John. They repented of their sins and were baptized.

Quite a few believed that John was the Messiah. The Jewish people were waiting for a king who would deliver them from their conquerors. This king they called the Messiah. John told them he was not the Messiah, but that the Messiah was already on earth and the people did not know Him. He was talking about Jesus.

Jesus was about thirty years old when He went to John to be baptized. John recognized Jesus as the Messiah and said to Jesus, "I should be baptized by You." But Jesus told John that he, John, had to baptize Jesus to fulfill the prophecy.

As John baptized Jesus, the heavens suddenly opened. The Holy Spirit, in the form of a dove, came out of the heavens. The dove rested on Jesus and the voice of God was heard. God said, "This is My beloved Son in Whom I am well pleased." This was a revelation of the Holy Trinity to the world: Father, Son, and Holy Spirit.

The icon of the Theophany of the Lord tells the story in color of what is said in words. In the Holy Icon there is a semi-circle in the upper half of the icon. This symbolizes the opening of heaven and indicates the presence of God the Father. From that half-circle are the rays of light. The dove is in the center of the rays, reminding us of the Holy Spirit. The central figure is the Son of God, Jesus.

In this Holy Icon, Jesus is in a waist cloth. Some icons show Christ unclothed. Christ blesses the waters of the Jordan River with His right hand. St. John officiates and places his right hand on the head of Christ.

Note the extraordinarily long arm of St. John. St. John sometimes is shown with a scroll in his left hand. The scroll is a symbol of preaching. In this icon, the left hand of John is in an upright position which is a gesture of prayer. St. John's beard is long and straggly. This shows he was living a very simple life in the wilderness.

Angels are also present in this icon. They are shown with their heads bowed and their hands are covered with cloaks and towels. The angels in this icon are attendants. They are present to help Christ when He comes out of the water.

The background of this icon has harsh, bold mountains. The angles are sharp and rugged. This tells that this event took place in the wilderness. The small tree in the upper part of the icon shows how that the area is uninhabited and desolate. There is very little vegetation and this indicates that this was a hard place for human beings to live.

Finally, in the river we can see a human figure riding a sea creature. In ancient times, people gave bodies of water human-like characteristics and names. The man riding a fish is a symbol of the Jordan River. Sometimes a woman riding a fish is also shown. She is a symbol of the oceans. Both are usually riding away from Jesus because they are amazed by the event of the Baptism of Jesus. A Psalm verse says: "The sea looked and fled, Jordan turned back" (Psalm 114:3).

THE PRESENTATION OF CHRIST IN THE TEMPLE

February 2

This feast is known in the Orthodox Church as The Presentation of Christ in the Temple. Another name for the feast is The Meeting of the Lord. Roman Catholic and Protestant Christians call the feast, The Purification of the Holy Virgin. About 450 AD in Jerusalem, people

53

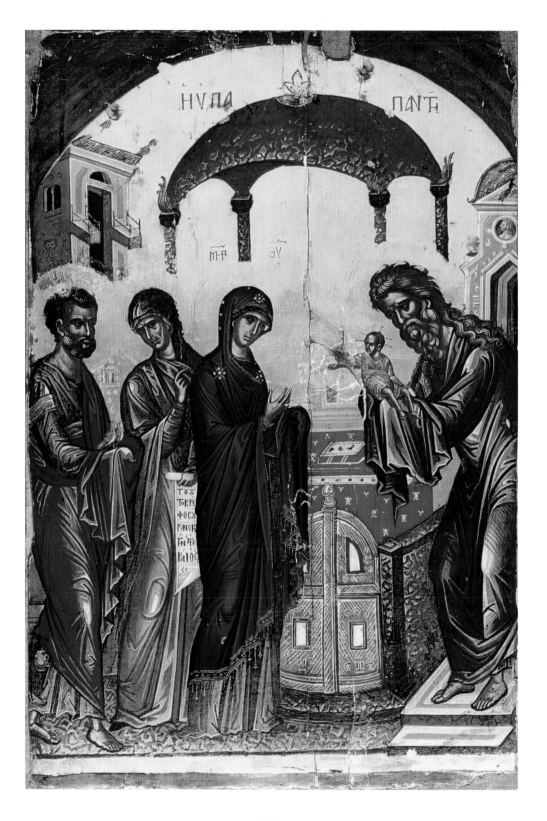

began the custom of holding lighted candles during the Divine Liturgy of this feast day. Therefore, some churches in the West refer to this holy day as Candlemas. Nevertheless, regardless of the name of this feast, it is celebrated on February 2.

The story of the Presentation is told in Luke 2:22-29. Mary and Joseph were faithful Jews and observed their religious customs. An important custom was for the couple to take their first-born son to the Temple. The baby was taken to the Temple forty days after his birth and was dedicated to God. In addition, if the parents were wealthy, they were to bring a lamb and a young pigeon or a turtle dove to be offered as a sacrifice at the Temple. The custom provided that if the parents were poor, they were to offer two pigeons or two turtle doves for the sacrifice.

When Jesus was forty days old, Mary and Joseph took Him to the Temple in Jerusalem. They were not wealthy, so they took two turtle doves with them to offer as a sacrifice at the Temple. As they arrived at the Temple, Mary and Joseph were met by a very old man named Simeon. He was a holy man and was noted as a very intelligent scholar. Simeon spent much time studying about the prophets of Israel. It was during his studies that he learned of the coming of the Messiah. The Jewish people were waiting for the Messiah to come and deliver Israel from their conquerors. From that time on, Simeon spent his time praying for the Messiah to come. He spent many years in prayer. Finally, while Simeon was praying he heard the voice of God. God promised Simeon that he would not die until he had seen the Messiah.

When Simeon saw Jesus, he took the baby in his arms and blessed the Lord and said: "Lord, now let Your servant go in peace according to Your promise, because my eyes have seen Your salvation which you have prepared before the face of all peoples, a light to bring revelation to the Gentiles, and the glory to your people Israel."

Also, in the Temple was Anna the Prophetess. She had been a widow for many years. Anna was about eighty-four years old and spent her time in the Temple praying. When she saw the Christ Child she thanked God and announced that the child is the Creator of heaven and earth.

The Holy Icon shows that the meeting takes place inside the Temple and in front of the altar. The altar has a book or a scroll on it

and is covered by a canopy. The Theotokos stands to the right and is holding out her hands in a gesture of offering. The one hand of the Theotokos is covered by her cloak or as it is known, the maphorion. She has just handed her Son to Simeon.

Christ is shown as a child, but He is not in swaddling clothes. He is clothed in a small dress and his legs are bare. Jesus appears to be giving a blessing. Simeon holds Jesus with both hands which are covered. This shows the reverence Simeon had for the Messiah. Simeon is bare headed and there is nothing to show that he is a priest. Some biblical scholars say that Simeon was probably a priest of the Temple or a Doctor of the Law.

Joseph is behind the Theotokos. He is carrying the two turtle doves for the sacrifice. Anna the Prophetess is also standing behind the Theotokos and is pointing to the Christ child.

The words Simeon spoke when he saw the Christ Child are known as "St. Simeon's Prayer." This prayer is sung daily at the evening Vespers services of the Orthodox Church.

In the Orthodox Church, both baby boys and baby girls are taken to the Church on the fortieth day after their birth. This is done in remembrance of the Theotokos and Joseph taking the infant Jesus to the Temple.

THE ENTRY OF CHRIST INTO JERUSALEM

Sunday before Easter

The story of this important feast is found in the Gospel of Mark 11:2-10. The most important feast of the Jewish people is the Feast of Passover. It celebrates the release of the Hebrew slaves from Egypt when they were led by Moses. The story of Jesus' entry into Jerusalem begins with many Jewish people going to Jerusalem to observe Passover. They wanted to pray at the Temple in Jerusalem.

Also, in this large group of people going to Jerusalem to celebrate the Passover, were Jesus and His disciples. Even though Jesus knew

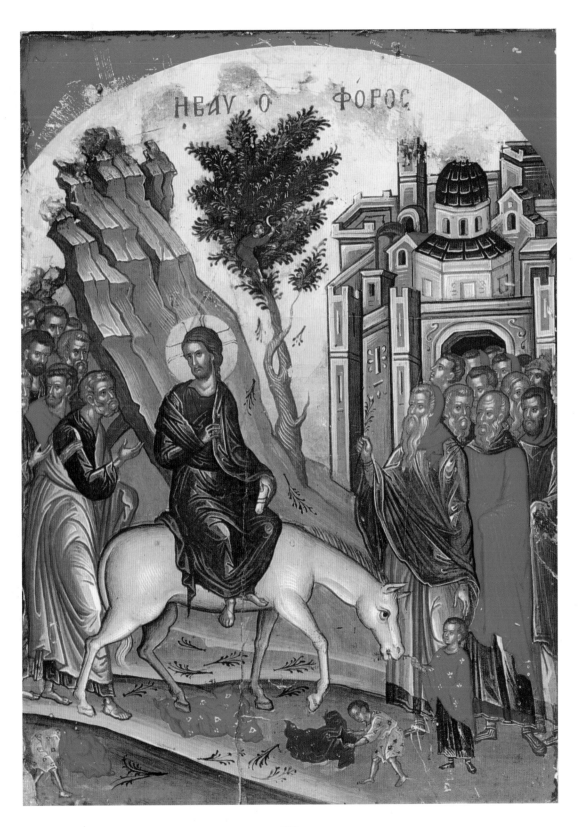

His service on earth was coming to an end, He was still performing His works. On His way to Jerusalem with His disciples, Jesus performed a great miracle. His friend Lazarus had been dead for four days, and Jesus performed the miracle of raising Lazarus from the dead. The news of this miracle spread to the people in Jerusalem. Of course, the people were amazed and very excited. They knew Jesus was on His way to Jerusalem and they were eager to see Him.

According to the Holy Scriptures, Jesus and His followers stopped outside of the city of Jerusalem at the Mount of Olives. Jesus talked with His disciples and asked two of His disciples to run an errand for Him. He told them to go to the nearby village of Bethphage and instructed them, "as you enter it you will find a donkey colt tied upon which no man has ever set. Untie him and bring the donkey colt to Me" (Mark 11:2).

The disciples did as they were told. They found the donkey colt and took it to Jesus. The disciples spread their coats on the donkey's back and Jesus rode it to Jerusalem.

The people of Jerusalem were so eager to see Jesus and they rushed out to meet Him. Some spread their cloaks on the ground in front of Him. Others cut branches from the palm trees and threw them on the ground in front of Him. The palm branches were symbols of joy. It was the custom of the Jews, at that time, to greet people of high rank with palm branches. They also gave branches of palms as rewards to conquerors. The people believed that Jesus was riding into Jerusalem to become the earthly King of Israel. They cheered and chanted, "Hosanna to the Son of David. Blessed is He who comes in the name of the Lord. Hosanna in the Highest."

The icon of The Entry of Christ into Jerusalem shows that it was a joyous occasion. The colors of the icon are bright and bold. The bright red cloak on the ground points out the happiness and excitement of the crowd. Christ is the main figure in the icon. He is shown riding on the donkey. An interesting fact to mention, is that on Russian icons, Christ is shown riding a horse instead of a donkey. The reason for this is that in many parts of the Russian the donkey is not known, but they have horses.

Notice that Jesus is looking somewhat back to the disciples, but yet He is looking towards Jerusalem. Jesus, with His right hand, is doing one of two things. He is either blessing the people or He is pointing towards the city of Jerusalem. The Disciple Peter leads the

other Disciples who are following Jesus. The people are coming out of the gates of Jerusalem to greet Jesus.

Even though the Holy Scriptures do not mention children, children are present in the icon. Children were eager to see Jesus. Also the children were not deprived of this event. In the icon children are shown taking an active part in the story. They are in the trees cutting branches. Even there are children spreading cloaks before Jesus.

The background gives information about the area. The mountains are shown with sharp angles. The area is rugged and desolate. The structures in the icon shows the city of Jerusalem.

This Holy Icon shows Jesus' journey to Jerusalem. Jesus knew that by going to Jerusalem He was voluntarily going to His trial, His suffering, crucifixion, and death. At the same time, this Holy Icon gives a hint of what is to come, His Resurrection.

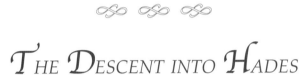

THE DESCENT INTO HADES

Pascha

Pascha commemorates the Resurrection of Christ. This is the greatest feast in the Orthodox Church. In the Orthodox Church, Pascha is not listed among the Twelve Great Feasts because it stands alone, above all the feasts. It is the Feast of Feasts. We also call this day Easter.

In the Orthodox Church, there are two icons showing the Resurrection of Christ. One is the Icon of the Myrrh-bearing Women. In this icon, an angel points to the empty tomb of Jesus. This is the story told in the Holy Scriptures. The Holy Scriptures announce that "Christ is risen." None of the Gospels – Matthew, Mark, Luke and John – describe the manner of Christ's Resurrection. Byzantine art, which is faithful to the Holy Scriptures, never shows the manner of Christ's Resurrection. Instead, Byzantine art shows what happened *before* or *after* the Resurrection.

The other icon of the Resurrection is the icon of The Descent into Hades. The four Evangelists do not tell of Christ's descent into Ha-

des. However, St. Peter tells of it in two places in the Bible. In Acts 2:31, which is part of Peter's sermon on the day of Pentecost. The disciples and a great crowd of people had gathered around them. Peter tells of the Resurrection of Jesus in his sermon. He told them that the soul of Jesus was not left in Hades and that the flesh of Jesus was not corrupted. That is, the flesh of Jesus did not decompose.

The second place where Peter tells of Christ's descent into Hades is in 1 Peter 3:19. Peter says, "He (Jesus) went and preached unto the spirits in prison." Spirits are the dead people and their prison is Hades.

The icon of The Descent into Hades shows that Christ is the Life-Giver. He has broken the gates of Hades and has trampled on Death. The Holy Icon has a very bright colored top portion and at the bottom of the icon is a dark abyss or pit. That abyss or pit represents Hades or Hell.

Christ is in the center of the icon. The darkness of Hell is surrounded by the brilliance of Christ. Christ is clothed in a bright golden-yellow garment. Before His crucifixion, Christ wore ordinary, plain clothing.

 Christ, with His right hand, is pulling someone up from the pit of Hell. The person is Adam. Eve, whom Christ has also risen from Hades, is in the red garment and she is standing watching what is happening. Christ freed their souls from Hades and also freed those who put their faith in His coming.

Behind Christ are the Old Testament prophets and saints. Heading the group are King David and King Solomon. They are wearing their crowns and royal robes. When they saw the Savior descend into Hell, they recognized Him and pointed Him out to the others. The New Testament saints are standing in back of Eve. St. John the Forerunner is standing next to Eve. This Holy Icon teaches that with all those that Jesus raised, all of humanity is also raised.

In the abyss of Hell are bolts, broken chains and keys scattered all around. This shows that those who were held captive by Death have been freed. Death has been tied up and made powerless by the resurrection of Christ.

The descent into Hell by Christ is that of a victor. Christ stands over the broken gate of the Kingdom and Death. Christ is victorious. Death's hold over man is broken.

THE ASCENSION OF THE LORD

Forty days after Pascha

Perhaps the shortest story told in the Holy Scriptures is the story of the Ascension of our Lord. This event, celebrated as one of the Twelve Great Feasts, is found in the book of Acts of the Apostles 1:3-11. It is celebrated forty days after Easter and always on a Thursday. The moment of the Ascension is told in one sentence: "He was lifted up before their eyes in a cloud which took Him from their sight" (Acts 1:9).

Christ made His last appearance on earth, forty days after His Resurrection from the dead. The Acts of the Apostles relate that the Disciples and the mother of Jesus, the Theotokos, were in Jerusalem. Suddenly, Jesus appeared before them. Jesus gave His Disciples some instructions for them to follow. He told the Disciples that they were to stay in Jerusalem for ten days. He then added that after ten days had passed the Holy Spirit would visit them.

After Jesus gave these instructions, He led the Disciples to the Mount of Olives and gave them further instructions. Jesus told them to go out into the whole world and to preach the Gospel to all nations. He also instructed them to baptize all people in the name of the Father, the Son, and the Holy Spirit. Finally, Jesus told them, "I am with you always, even to the end of the world." Then Jesus lifted His hands, blessed the group, and was lifted into heaven.

Obviously, the Disciples were amazed. They kept watching Jesus as He ascended into heaven. Suddenly, two angels appeared to them and asked them why they were gazing into heaven. Then the angel said, "This same Jesus, which is taken up from you into heaven, shall so come in like manner as you have seen Him going into heaven" (Acts 1:11). When the Disciples heard this they fell to their knees and worshipped God.

The icon of The Ascension of Our Lord is a joyous icon. It is

painted with bright colors. Looking at the icon, the story it is telling doesn't seem right. It seems that Christ should be the main person in this icon. However, the icon seems to make the main people of this event the Theotokos, the angels, and the Disciples. Christ, who is ascending into heaven, is the important person of this event, but, He is shown smaller than the other figures.

The Theotokos occupies a very special place in this icon. She is in the center of the icon, immediately below the ascending Christ. The gesture of her hands is gesture of prayer. She is clearly outlined by the whiteness of the garments of the angels. The Theotokos is depicted in a very calm pose. This is quite different from the appearance of the Disciples. They are moving about, talking to one another and looking and pointing towards heaven. The entire group, the Theotokos and the disciples signify the Church of Christ.

Christ is shown ascending in His glory and He is in a mandorla. A mandorla is a design which is almond-shaped or round. Inside the mandorla is the figure of a holy person. In this icon the sacred figure is Jesus. The mandorla symbolizes the heavens. The mandorla seems to be supported by the angels. Our Savior does not need their support. He ascended into heaven under His own power. The angels are there to glorify Him.

Christ blesses the assembly with His right hand. In His left is a scroll. The scroll is a symbol of teaching. This icon shows that the Lord in heaven is the source of blessing. In addition, Jesus is the source of knowledge. We, the people, get this knowledge through the Church.

Again, Byzantine art is true to the account in the Holy Scriptures. The story in Acts 1:12 tells that the Ascension of our Lord took place on Mount Olivet. In this icon, that place is shown by the olive trees in the background. The olive trees are depicted growing in the rock soils of that area.

The icon of the Ascension includes some who did not witness the Ascension. St. Paul is shown to the right of the Theotokos, but we know that he was not present at the Ascension. At that time, St. Paul did not yet believe in Jesus. But he became a Christian and went on to become one of the greatest Apostles of Christ. The presence of St. Paul is purposely depicted in the icon to show that the whole Church witnesses this event.

The Descent of the Holy Spirit (Pentecost)

Fifty days after Pascha

The Feast of Pentecost has its beginnings in the Old Testament. It is a feast celebrated by the Jews fifty days after Passover. The Pentecost of Judaism celebrates the giving of the Ten Commandments to Moses on Mount Sinai. It also celebrates the end of the grain harvest. The people gave thanks for their crops of wheat and barley.

The day of Pentecost is also the fiftieth day after Christ's Resurrection. It was on this day that the Holy Spirit descended on the Apostles. On this day, the Church began.

The Disciples, as the story is told in Acts of the Apostles, chapter 2, were sitting together in the upper room of their home. Suddenly, a loud sound was heard. It seemed that this sound came from a great wind. Much confusion occurred in the room. This wind filled the room and great tongues of fire appeared over the heads of each Disciple and the Theotokos. They were filled with the Holy Spirit as Jesus had promised and the angels had reminded them at the time of our Lord's Ascension into heaven.

The Holy Spirit gave knowledge to the Disciples and they remembered everything that Jesus had taught them. In addition to being filled with the Holy Spirit, the Disciples were able to speak in different languages. The Disciples, filled with the Holy Spirit, were confident and were able to go out into the world to preach about Jesus.

Since this day was the day of the Jewish Pentecost, there were many people from all parts of the world in Jerusalem. They came to celebrate the feast. Now the news of what happened to the Disciples spread throughout the city. The people were curious and gathered

outside of the Disciples' home. When the crowd heard those Disciples, who were not educated men, speaking different languages, they were surprised. In fact, they were puzzled. They could not believe what they were hearing. Some people thought that the Disciples had drunk too much wine and become drunk!

Peter heard these comments and was greatly disturbed. He stood up with the other Disciples and told the crowd that the Disciples were not drunk. Peter, then, preached to the crowd. He preached about the Resurrection of Jesus and that he was the Messiah. Upon hearing his words, people asked, "What then must we do?" Peter responded that they should repent from their sins and be baptized in the name of Jesus. According to Acts of the Apostles, over 3000 people were baptized and became Christians that day.

The icon of Pentecost, The Descent of the Holy Spirit, is an icon of great joy. The bright, bold colors of red and gold indicate it is a great event. According to the story in the Holy Scripture there was much confusion and noise when the Holy Spirit descend on the Disciples and the Theotokos. But, the Holy Icon does not show this. Instead, the Disciples appear very dignified, calm and in a thoughtful mood.

Twelve men are sitting in a semicircle which shows the unity of the Church. Note that in the center of the semicircle is an empty seat. This unoccupied seat is the place of the invisible head of the Church — Jesus. At the head of the semicircle is St. Paul. He is sitting to the right of the invisible head of the Church. The Evangelists are shown holding books. The Evangelists are the inspired writers who wrote the Gospels. They are Matthew, Mark, Luke and John. St. Luke the Evangelist, is the third person from the top on he right. The third person from the top on the left is St. Mark the Evangelist. The others are holding scrolls. These scrolls are signs that they received the gift of teaching.

The semicircle at the top of the icon has rays coming out of it. The rays are falling on the Disciples. At each end of the rays are red "tongues of fire." This shows two things: the baptism with the Holy Spirit and fire and the Holy Spirit descended in the form of tongues.

Jesus gave His Disciples instructions that they were to go out into the world to preach. At the bottom of the icon in a cave-like structure is a king-like figure. This figure is Cosmos and he represents all of the people of the universe. He is an old man and is sitting in a dark

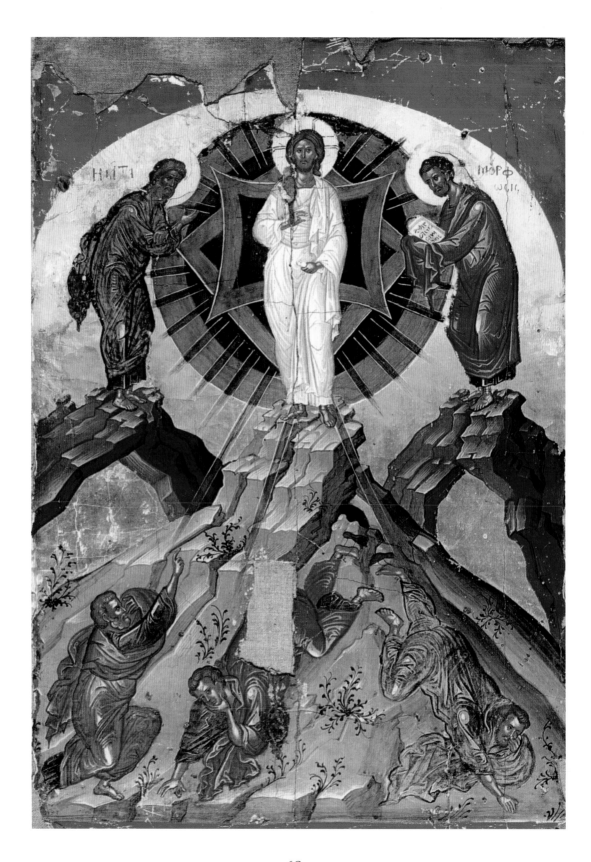

68

place. Cosmos is dressed in a royal, scarlet robe and has a crown on his head. In his hands he is holding a cloth containing twelve scrolls. Cosmos is sitting in darkness for the entire world has been without faith. The twelve scrolls represent the Twelve Disciples. The Twelve Disciples, through the power of the Holy Spirit, brought light of the Good News of Jesus to the whole world by their teaching.

The message of the Holy Icon is addressed to the faithful members of the Church. It teaches that Pentecost is the beginning of the Church.

THE TRANSFIGURATION OF CHRIST

August 6

A great and notable feast in the Orthodox Church is The Feast of the Transfiguration of Christ. The word "transfiguration" means a transformation, or an alteration of a figure In this feast, it means the alteration or change in the appearance of Jesus Christ.

The Holy Scriptures give several accounts of this event. The story is found in the Gospels of Mark (9:2-10); Matthew (17:1-9); and in Luke (9:28-36). The main event of the story takes place on a mountain. The Holy Scriptures give two accounts of the Transfiguration of our Lord. In the Gospels of Mark and Matthew, it is reported that when the Disciples heard the voice of God the Father and saw the bright light, they fell down. According to the Gospel of Luke, the Disciples saw the transformation of Jesus when they awoke from their sleep.

According to the Holy Scriptures, one day Jesus was speaking with His Disciples. He told them that some would not die until they had seen the kingdom of God. About eight days after Jesus said this, He took His disciples Peter, James, and John up a mountain. This mountain is known as Mount Tabor.

The trip up the mountain was a long and tiresome journey. Finally they reached the top of the mountain. The Disciples were exhausted. Instead of praying, they fell asleep. Jesus did not sleep,

but spent His time in prayer.

As Jesus was praying, His whole body changed. His body shone like a great light and His clothing became glimmering white. Two men appeared and talked with Jesus. They were the Old Testament prophets Moses and Elijah. A tradition says that the three — Jesus, Moses, and Elijah — were talking about the coming crucifixion of Christ.

A great light surrounded the transfigured Christ. This light was so bright that it woke the sleeping Disciples. They saw Jesus talking to Moses and Elijah. The Disciples were frightened, but awe-stricken at what they were seeing. They could not talk. Finally, Peter recovered and was able to speak. He said, "Lord, it is good for us to be here."

While Peter was speaking, a cloud came down and covered the disciples. A voice came out of the cloud and said, "This is my Beloved Son: Hear Him." It was the voice of God. When the voice was finished, the Disciples were amazed. Now they were alone again with Jesus.

After this, the Disciples and Jesus started back down the mountain. Jesus told Peter, James and John that, for the time being, they should not tell anyone about the events they had witnessed. They were instructed to tell of this event only after Jesus had risen from the dead. Jesus, by allowing the three Disciples to witness the transfiguration, He gave them a glimpse of His divinity and the life that is to come.

The icon of the Transfiguration is a bright icon with much gold and light colors. Christ is standing at the top of the mountain in shining, white garments. The mandorla (the oval shaped figure with Christ in the center) has a geometrical figure in back of Jesus. This geometrical figure represents the cloud. The three large rays are pointed at the three disciples. This shows that the action is from the Holy Spirit. The two figures standing with Christ are Moses and Elijah. Moses is holding the Ten Commandments. Elijah is on the other side of Christ and he represents the prophets. Moses and Elijah are important figures in this icon. First, they represent the law and the prophets. Second, both had a vision of God — Moses on Mount Sinai and Elijah on Mount Carmel. Finally, Moses represents the dead, while Elijah, who was taken to heaven in a chariot, represents the living.

The Disciples Peter, James, and John appear at the bottom of the

icon. They are the same three Disciples who will be at Gethsemane with Jesus. Peter, James, and John are being prepared for the Passion, but are not able to understand it. The three disciples have fallen from the rugged top of the mountain as they are stunned by the bright light. St. Peter is kneeling. His hand is raised to protect himself from the glaring light. St. John, who is in the center of the group, falls and has turned his back on the light. St. James has fallen backwards and is trying to escape the light.

<p style="text-align:center">∃ ∃ ∃</p>

THE ELEVATION OF THE HOLY CROSS

September 14

An important Feast Day of the Orthodox Church is celebrated on September 14. This is The Feast of the Elevation of the Holy Cross. This important feast day is the only one of the Twelve Great feasts which does not celebrate an event in the life of Christ or the Theotokos. The Feast of the Elevation of the Holy Cross celebrates four great events about the Holy Cross.

The Holy Cross is praised by all Christians. Orthodox, Roman Catholic, and many other Christians make the sign of the cross in their prayers. The priest blesses us with the sign of the cross. The cross is on churches. People wear small crosses around their necks.

The stories of the events for this feast day are found in Church history. The first story of this feast happened to Constantine in 312 AD. Constantine was preparing to fight his enemy, Maxentius. It was a very important battle because whoever won this battle would become the ruler of the Roman Empire.

The night before the battle, Constantine saw something in the sky. It was a Cross with these words, "By this sign conquer." At this time, Constantine was not a Christian, but he was emotionally moved by this sign. He ordered all his soldiers to put a cross on their shields before they went into battle. Constantine and his troops won and Constantine became the ruler of the Roman Empire.

The second part of this event involves St. Helen. She was the

mother of Constantine and she was a Christian. St. Helen wanted to see for herself the lands where Jesus lived and died. Constantine, who respected his mother, sent her, along with her servants and soldiers to guard them, to Jerusalem. St. Helen made several trips to Jerusalem. On her trips, she had many churches built. But the greatest thing that happened on one of her trips was that she found the Holy Cross on which Christ was crucified. The Holy Cross was found under a mound at Golgotha. The Holy Cross remained with the Church of Jerusalem.

St. John Chrysostom in 395 AD wrote about St. Helen finding the Holy Cross. He tells how St. Helen found at Golgotha a mound. This mound had the herb sweet basil growing on it. When St. Helen had her servants dig up the mound they found three crosses. The cross in the middle had a sign on it with these words, "Jesus of Nazareth, King of the Jews." This was the sign placed over the head of Jesus when He was crucified. This told St. Helen that this was the true cross of Jesus. St. Helen let the Holy Cross remain with the Church of Jerusalem.

The third event, which is remembered on September 14, is called the "Elevation of the Cross." After Constantine had recognized Christianity, he ordered a church erected at the place of the Holy Sepulcher. The Holy Sepulcher is another name for the place of the tomb of Jesus. The Church was named "The Resurrection" and was dedicated on September 14, 335 AD. However, something important happened that day. The Bishop of Jerusalem, Makarios, wanted the people to see the Holy Cross. So, he brought the Holy Cross out of the church and raised it up high so everyone could see it. The faithful people were so glad, but yet awed to see the Cross that they cried out "Lord, have mercy" – "Kyrie Eleison."

The fourth event takes place several centuries later in 629 AD. This event celebrates the return of the Holy Cross to Jerusalem. In 614 AD the Persians had invaded the Holy Lands. The Persians were not Christians and did not respect the Holy Cross. In one hard-fought battle, they took the Holy Cross away from Jerusalem. The Persians knew how important the Holy Cross was for the Christians. The Christians were very upset by this act and they kept fighting the Persians. This war lasted for fifteen years. Finally, Emperor Heraclitos, in 629 AD recovered the Holy Cross from the Persians. He took the Holy Cross to Constantinople. In a great celebration and a magnificent ceremony at the Church of Hagia Sophia (Holy Wisdom), the emperor

lifted up the cross for all to see and venerate. The second exaltation of the Holy Cross is also celebrated on September 14.

Now, the Church fathers knew that the Holy Cross was not safe. The Arabs were always trying to invade the Holy Land and the Holy Cross was forever in danger of being captured. So, when the Holy Cross was returned to the Christians, a decision was made to cut up the cross. They felt pieces of the cross would be safe if pieces were given to the great centers of Christianity. The Church fathers sent sections of the Holy Cross to Jerusalem, Constantinople, Alexandria, Antioch, and Rome.

These four events, the vision of the cross seen by Constantine; the finding of the cross by St. Helen; the construction and dedication of the church of Resurrection; and the return of the cross to Jerusalem, make up the Feast of the Elevation of the Holy Cross.

The icon of The Elevation of the Holy Cross tells the story of these events. In the center of the icon, Bishop Makarios is standing at the pulpit elevating the Holy Cross. He is holding the Holy Cross with his two hands, high over his head, so the people can see it. On either side of the bishop are deacons holding candles. Monks and priests are also shown. Also pictured are hymnographers, the people who write the hymns for the Church. They are the people with the pointed hats. St. Constantine is standing below the pulpit on the right side of Bishop Makarios. On some icons, St. Helen is also shown with her son, Emperor Constantine. The saint on the left of the pulpit is St. John Chrysostom. He is pictured there because he told how St. Helen had found the true Cross.

In the background, the structure on the right side with the dome, represents the church of the Resurrection in Jerusalem. This structure is there to remind us that Constantine ordered the construction and dedication of this great church. The wall indicates that the action of the event takes place outdoors.

The icon shows the events: Constantine who legalized Christianity, Helen who found the Cross; and Makarios who showed the Cross to the people during the dedication of the Church of the Resurrection. The Holy Cross is powerful. It is a weapon of peace. Its power spreads to every part of the world. For this reason, during the celebrations of this great feast, the priest turns in blessing each point of the compass — north, south, east, and west — and chants, "The four ends of the earth, O Christ our God, are blessed today."

GLOSSARY

A

ABYSS - a bottomless pit; a deep pit; hell

ANGEL - a divine messenger; a spirit; a spirit created by God before man was created.

ANNUNCIATION - A feast celebrated to commemorate the visit of the Archangel Gabriel to the Theotokos. He announced that she was to be the Mother of the Son of God. The feast is celebrated on March 25.

APOCRYPHA - Certain Old Testament books not considered inspired by God. These books, though, are included in the Orthodox and the Roman Catholic Bibles.

APOSTLE - from the Greek meaning "one who is sent;" one sent to preach the Gospel; one of the twelve disciples. The name given by Christ to the Twelve Disciples.

ARCHANGEL - an angel of the highest order

ASCENSION DAY - A movable feast day which is observed forty days after Easter. It commemorates the Ascension of Christ into heaven.

ASSUMPTION - The feast day commemorating the Falling Asleep of the Theotokos.

B

BAPTISM - an immersing in water. A Sacrament washing away original sin and joins people baptized to the Church

BETHLEHEM - A town of Judea; birthplace of Jesus.

BIBLE - Sacred books including Old and New Testaments. The Holy Scriptures

BIER - The frame which a coffin is placed; the coffin and its stand

BYZANTINE - pertaining to Byzantium or Constantinople and the Greek Empire of which it was the capital. Style of architecture popular with Orthodox Churches, developed in Byzantium, later called Constantinople. Now called Istanbul.

C

CANON - a rule of doctrine or discipline; a law

CANON LAW - Rules or laws relating to faith, morals and discipline as prescribed by Ecumenical Councils and Holy Fathers.

CHRISTIAN -a follower of Christ. One baptized into the Church to become a follower of Christ. Followers of Christ were first called Christians in Antioch, Syria.

CHURCH - A house consecrated to the worship of God. the collective body of Christians

CHURCHING - To receive a service in church after giving birth to a child, usually on the fortieth day. This service corresponds to the Feast of Presentation of Christ in the Temple.

COSMOS - the Universe

CREED - A brief summary of the articles of the Christian faith; Articles of faith drawn up by the Ecumenical Councils (Nicene Creed).

CROSS - that on which Christ was crucified. An upright supporting a horizontal beam. Ancients used it in the execution of criminals.

CUPOLA - a dome. The steeple dome found on most Orthodox Churches. A church may have a single dome or as many as thirteen. One dome that is larger than the others signifies that Christ is the head of the Church.

D

DAVID - The youngest son of Jesse of Bethlehem. He slew Goliath with his sling and charmed Saul with his harp. He incurred Saul's ill-will and was driven to outlawry. After Saul's death, David ruled Israel for forty years.

DISCIPLE - follower of person or idea; somebody who strongly believes in teachings of a leader.

DIVINE LITURGY - Church service celebrating the Holy Eucharist

DOCTRINE - a rule which is taught

DORMITION - sleeping

E

EASTER - A festival of the Christian Church in remembrance of Christ's resurrection. Known as Pascha, the Feasts of Feasts. Greatest Church day of the Orthodox year.

ECUMENICAL COUNCIL - An assembly of the representatives of the Church, meeting to settle ecclesiastical (church) affairs, formulate dogmas, and make rules of faith and morals. The Orthodox Church recognize Seven Ecumenical Councils.

ELIJAH - A great Hebrew prophet of the ninth century B.C.

EPIPHANY - Feast celebrating the visible manifestation of Christ. The Baptism of Christ and the manifestation of God in the Holy Spirit through the descent of the Holy Spirit. Theophany is another name for Epiphany.

EPISTLE - a letter

EVANGELIST - Inspired writers of the four Gospels — Matthew, Mark, Luke and John.

F

FATHERS OF THE CHURCH - Early Christian writers and defenders of the faith. A few of the known Fathers are St. John Chrysostom, St. Basil the Great and St. Gregory the Theologian.

FEAST - A holy day celebrating an event in the life of Jesus, the Theotokos, or some saint.

FRANKINCENSE - a naturally perfumed gum-resin used as a perfume.

FRESCO - A scene on a wall or ceiling of a Church which is painted on wet plaster.

G

GARDEN OF GETHSEMANE - The enclosure outside of Jerusalem, scene of agony and arrest of Jesus.

GOD - The Supreme Eternal Almighty Spirit. The Creator of all things.

GOLD - a precious metal of bright yellow color.

GOLGOTHA - from Hebrew meaning skull; a place of suffering; a place of burial. The place where Jesus was crucified.

GOSPEL - The history of Jesus Christ; any of the four records of Christ's life by His Apostles. Portions of the Scriptures read by the priest during the Divine Liturgy.

H

HALO - A circle of light, appearing to surround a body.

HAGIA SOPHIA (HOLY WISDOM) - Famous church in Istanbul (Constantinople) was first built in 415 AD. Burned and was rebuilt by

Justinian in 532 AD. Was the largest church until the building of St. Peter's in Rome.

HEAVEN - The place of perfect blessedness where those who are saved shall be in the full light of God's presence and love forever.

HELL - The place or state of punishment for the wicked after death. The home of the devil and his followers. The place and state of condemnation where lost souls are tormented forever.

HOLY - free from sin; sacred.

HOLIES OF HOLIES -The innermost part of the Jewish tabernacle and temple where the Ark of the Covenant was kept.

HOLY SPIRIT - Third Person of the Holy Trinity.

HOLY TRINITY - There is one God in three Persons — the Father, the Son, and the Holy Spirit.

HOLY TRADITION - The spiritual treasures inherited through the life of the Church, in accord with the Scriptures but larger in extent.

HOSANNA - From the Hebrew which means "O lord, save, we pray."

HYMNOGRAPHER - one who writes hymns for the Church.

I

ICON - A sacred picture.

ICONOCLAST - A breaker of icons. An opponent of the use of icons.

ICONOGRAPHER - one who paints icons.

INCARNATION - The Feast of the Birth of Jsus, also known as the "Incarnation of Christ." We also refer to this joyous feast as Christmas.

J

JERUSALEM - In Biblical times the chief city of Israel. It is the chief city of the Holy Land and to the Christians the most illustrious in the world.

JESUS CHRIST - God the Son, the Second Person of the Holy Trinity. He is one person with two natures, God and man.

JUDEA - The land of the Jews

M

MAGI -A class of priests among the ancient Medes and Persians; holy men of the East.

MANDORLA - A round area on an icon which has an image of a sacred person.

MANKIND - the human race

MANIFESTATION - that which is evident to the senses especially to sight.

MARTYR - One who suffers death or persecution on account of his or her belief. To be put to death for adhering to one's belief.

MESSIAH - The Anointed One; Christ, the Anointed

METROPOLITAN - The head of an ecclesiastical province.

MIDWIFE - A woman who assists women in childbirth.

MONASTERY - A place for monks to live who lead a life of prayer under vows.

MONK - A person who renounces the world to lead a religious life under the monastic vows of obedience, poverty, and celibacy.

MOSES - The great Hebrew prophet and law-giver who led the Israelites out of Egypt.

MOTHER OF GOD - The Theotokos, Virgin Mary. Jesus, born of her as man, is also God.

MYRRH - An aromatic gum-resin from a spiny Arabian shrub. Sacred oil used for anointing in the Sacrament of Chrismation.

N
NIMBUS - A circle of a radiant light around the heads of saints

P
PATRIARCH - A title used by many heads of national churches in the Orthodox world.

PENTECOST - the descent of the Holy Spirit upon the disciples on the fiftieth day after our Lord's Resurrection.

PERSECUTIONS - To harass with unjust punishment. Periods of ill-treatment and oppression because of religious beliefs. In the first three centuries of Christianity there were many persecutions.

PERSIAN - One of the ancient Iranian Caucasians who under Cyrus and his successors became the main Asiatic race.

R
REGENT - acting on behalf of another; representing another.

RESURRECTION OF CHRIST - Christ's rising from the dead.

REVERENCE - awe combined with respect; veneration.

S

SAINT - One noted for piety and virtue; one of the blessed. One who had led a pure and holy life, whose life has been inscribed in the list of saints and whose memory is celebrated on a given day.

SANCTIFY - To make free from sin or to purify.

SANCTUARY - A consecrated place; the most sacred part of any religious building. The temple of Jerusalem, the holy of holies housing the ark of the covenant.

SALVATION - redemption of man from sin.

SCROLL - A roll of paper or parchment.

SEE - A seat of episcopal power; a diocese.

SERAPHIM - An order of heavenly beings.

SHEPHERD - One who tends sheep.

SYMBOL - A sign; an emblem.

SYMBOLIZE - To represent by a symbol.

SWADDLING CLOTHES - Bands or clothes wrapped around a newborn infant.

T

TEMPLE - A place of worship.

THEOTOKOS - Greek meaning God-bearer. The Virgin Mary, Mother of God. The chief title assigned to the Blessed Virgin Mary in the theology and worship of the Orthodox Church. The Third Ecumenical Council at Ephesus in 431 AD decreed that she should be honored by this name.

TRANSFIGURATION - A change of form or figure the supernatural change in the appearance of Christ on the mount; a church feast held on August 6 in commemoration of this change.

THEOPHANY - Also known as Epiphany. The appearance of God to mankind.

V

VESPERS - Evening services

VIRGIN MARY - Another name for the Theotokos, the Mother of Jesus.